Judith von Halle, John Wilke

The
REPRESENTATIVE
of HUMANITY

between Lucifer and Ahriman

The Wooden Model at the
Goetheanum

Sophia Books

Sophia Books
Hillside House, The Square
Forest Row, RH18 5ES

www.rudolfsteinerpress.com

Published by Sophia Books 2010
An imprint of Rudolf Steiner Press

Originally published in German under the title *Die Holzplastik des Goetheanum* in 2008 by Verlag am Goetheanum, Dornach.

Translated from German by Pauline Wehrle and John Wilkes

A catalogue record for this book is available from the British Library

ISBN 978 1 85584 239 7

Cover by Andrew Morgan Design
Typeset by DP Photosetting, Neath, West Glamorgan
Printed and bound in Malta by Gutenberg Press Ltd.

Contents

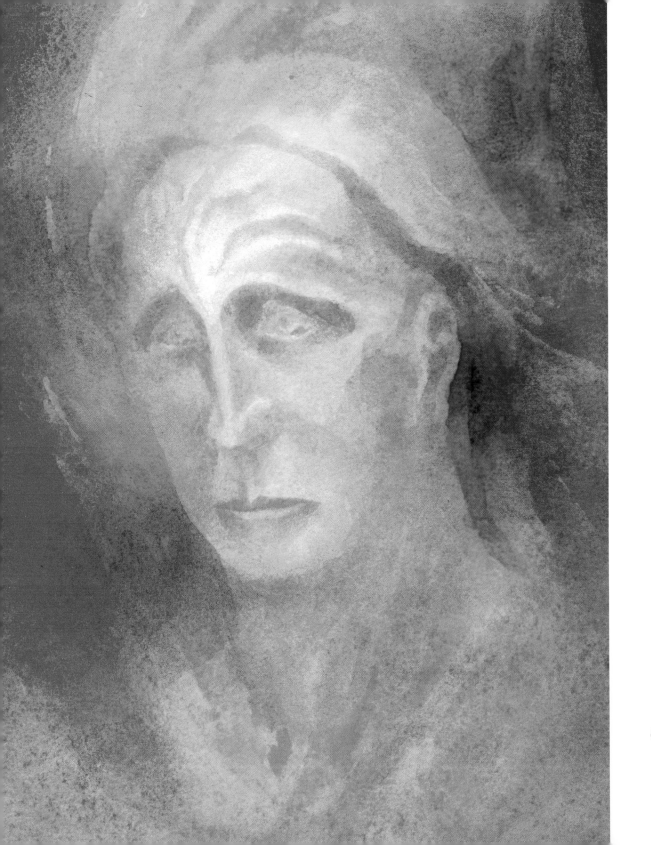

(Gabriela de Carvalho)

Foreword

As the basic book *Rudolf Steiner's Sculpture in Dornach* by Åke Fant, Arne Klingborg and John Wilkes 1969 (English Edition 1975) has been out of print for many years the present volume comes as a renewed contribution to this work of art, the importance of which is being recognized by more and more people.

By a happy stroke of destiny it was produced as the joint effort of Judith von Halle, who had already devoted herself to an earlier publication on the spiritual dimension of the 'Group', and the English sculptor John Wilkes, to whom we owe the salvation of almost the whole of the preparatory activities of Rudolf Steiner and Edith Maryon in the realm of sculpture and architecture.

This book gives me the opportunity to thank John Wilkes on behalf of the Fine Arts Section most heartily for his selfless engagement in this work.

Ursula Gruber
Leader of the Fine Arts Section
Dornach, January 2008

I look upon your karmic path
Of little joy
I see your noble Spirit striving
Soul warming:
And I behold a Human Being's sense of deed
In your earthly wanderings.

I feel your very quiet being
So loving
I am aware of your Soul's great striving
Never waning:
And I behold a Human Being's sense of love
Out of your daily living.

I stand before your gate of death
All too near
I sense the deep and painful path
Patiently carried:
And I behold a Human Being's sense of calm
From your bed of suffering.

I am delighted by your beauteous spirit work
Solemnly conducted
I am aware of your dedicated life
The spirit goal:
I behold a Human Being's power of sacrifice
Out of your Soul's endeavouring.

I enter into Spirit worlds
Full of blessings
Your future weaving life of Soul
Radiating light:
And I behold a Human Being's spirit power
Out of your infinite Being.

From lofty Sun I am aware
Love's warming
Your shining gaze streams down to us
Offering help:
And I behold a Human Being's blessing power
Out of your active Spirit.

— Rudolf Steiner, from his address at Edith Maryon's funeral.

(Translation by A and AJW. For source see note 10.)

Preface

The content of this book is intended to offer the interested visitor to the wooden sculpture in the Goetheanum some idea of the relationships, development and intentions of this work of art.

On the other hand this does not mean that every detail of the so-called 'Group' will be explained. This would not even be possible. Even if this were to be attempted one would be standing in front of something that could no longer be experienced as a true work of art. A true work of art declares itself without intellectual explanation; it is there to awaken in the soul of a human being nourishment and encouragement to be active.

It was Rudolf Steiner's intention from the very beginning that art should speak to the human being in such a way that independent research becomes inevitable. The intention of this book is therefore explicitly to offer indications regarding the realm and content out of which the work arises, about the environment in which it is situated and the artists who created it.

In the following pictures in which the figures are intro-duced, the full-size plasticine model is referred to. This model, still largely extant, stands in the so-called Hocha-telier next to the extensive joinery workshops immediately south-east of the Goetheanum. The reason for this is that the carving, which is exhibited in the 'Gruppenraum' within the Second Goetheanum, was not completed in Rudolf Steiner's lifetime and therefore cannot be completed. Although one experiences the powerful impact of this immense work as a totality in wood, the model can offer in addition impressive insight into the artist's detailed intentions. Repeatedly work on the model would be revised by Rudolf Steiner, demonstrating the continual spiritual movement evident in the whole series of small models, and the metamorphic processes which developed over an eight-year period. It must be clearly understood that the artist would not have copied the model to complete the carving; the model was only necessary for major practical but definitely not artistic purposes.

Judith von Halle, John Wilkes

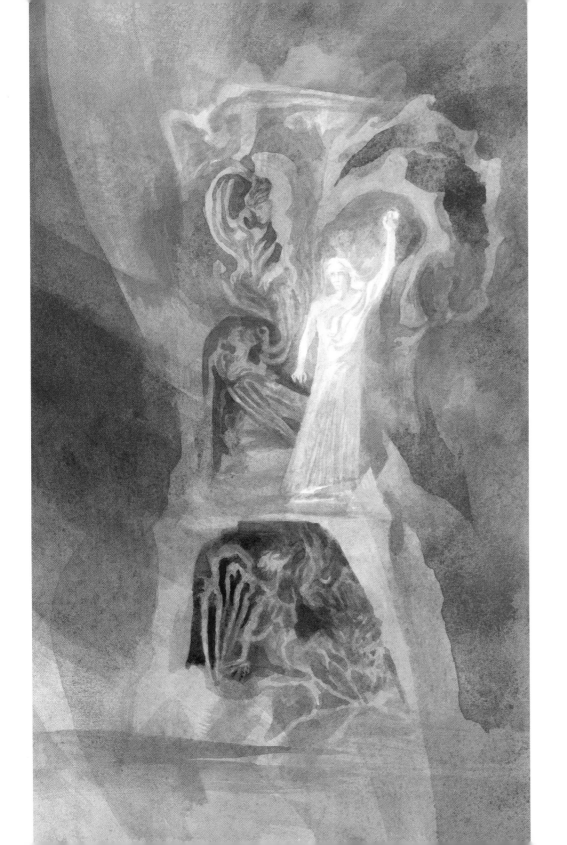

(Gabriela de Carvalho)

The Representative of Humanity — An Overview

John Wilkes

The wooden sculpture in Dornach, which is today exhibited in a specially designed space in the Goetheanum and is available to be viewed by the public, stands before us as a monumental creation. We are nevertheless obliged to place this carving in the category of an unfinished work, but this however does not detract from its importance. For any artist a work of this size and content would have been an immense task, but Rudolf Steiner was also for the most part travelling on lecture tours around Europe. The sculpture thus only became possible through the devoted work of Edith Maryon, an English trained sculptress who was first able to make initial steps with the composition in the autumn of 1914 in a small model. Even during this year Rudolf Steiner was very little in Dornach while the First Goetheanum building, in which the sculpture was to be the central feature, was being erected. During 1915 the collaboration led to five further models followed by the full-size, 9.5 m high construction in 1916.

Due to the demands of producing such a huge wooden sculpture, necessitated by the scale of the building itself, together with its profound spiritual intentions, it was essential to make a full-size model. This is not a process the carver relishes, but in this case it was essential. It facilitated the procedure of gluing plank-by-plank the individual blocks as close as possible to the size needed for each figure.

A number of artists helped to prepare the carving constantly under the watchful guidance of Edith Maryon;

Rudolf Steiner himself was able to oversee carving of the figure in the cave below, the only one that can be considered in the main to be finished; he worked on the central figure which also remains incomplete, but the other four figures remain untouched by him. Just these four figures however, thoroughly worked over by him in the full-size model, do still exist and can be studied in detail. From the two figures which were removed according to his instructions, as they were no longer needed, there remains photographic evidence.

Confronted with the sculpture we become aware of a freestanding human figure, left arm raised, right arm lowered. This gesture indicates an inner state of consciousness, namely one of holding a balance between two opposite tendencies. It is these two opposite tendencies of contraction and expansion welded together that make physical human existence feasible within nature on our planet.

This is not a religious sculpture but one that has to do with the destiny of the whole of mankind. Nevertheless this Representative of Humanity is for Rudolf Steiner the Christ Being who entered the body of Jesus at the Baptism. The Christ Sun Being borrows the sheaths of Jesus into which to incarnate. He who can now be named Jesus Christ moves away into the desert and there experiences the three so-called Temptations: firstly the approach of Ahriman, secondly that of Ahriman and Lucifer together, and finally the approach of Lucifer. These two names, used since

ancient times, refer to beings that also appear for instance as black and red devils in medieval paintings. As they are unable to overcome this incarnating Sun Being, Ahriman crawls away into his domain and binds himself in the gold veins within the bowels of the earth, while Lucifer breaks his own wings and thus casts himself into the abyss. We are offered by means of this central gesture an indication of mankind's task throughout the Earth's evolution to bring about a balancing redemptive harmony of these two beings. At the same time we have an indication of the resurrection process taking place after the Mystery of Golgotha. So we have in an extraordinary way encapsulated in this sculpture the whole of Christ's mission on earth during His three years.

These two opposite forces relating, on the one hand, to Ahriman and contractive tendencies and, on the other, to Lucifer and expansive tendencies are portrayed here in human form. In other words if the human being were to be overwhelmingly dominated by either, the human forms would be dramatically distorted in such a way.

Below in the cave we experience a painfully sclerotic ahrimanic organism under extreme tension and ultimate spasticity. The skeleton is really externalized with boniness dominating in every organ. This is a figure for which one can only feel infinite compassion, despite its immense and desperate power. Above on the right is a huge downward-surging concave luciferic form within a process of cataclysmic self-annihilation, a broken being of light and expansiveness.

Both are unable to express themselves in their full demonic power in the presence of the truly human, uncompromisingly harmonic and compassionate Christ Being. However on the left, as though in another space and time, we see them again from another point of view, components of the human but revealed in their separated aspects. This composition of the interrelating opposites gives an indication of their ultimate task, namely this manifestation of the central human figure. In the two figures we experience opposite components distilled out and revealed more in their true nature. But in this union they cannot exist adjacent to the central figure, so what happens to them is revealed on the right and below.

The overall composition of this sculpture, which gradually developed through a series of models, consisted at first solely from the three figures on the right. It became necessary to indicate this second relationship, which shows the bonded powers before their demise. This technique of showing in two situations a metamorphosed condition of such entities dissolves the possible criticism of a dogmatic judgement.

The central gesture, the left arm raised and emanating with rhythmical forms from the heart region, attempts an anchoring of the flying off, disintegrating impulse of Lucifer. The right arm, linking with the enlightened nerve-centred head in a downward gesture, attempts to alleviate the condition of the cramp-dominated Ahriman below.

All these relationships reveal sculpturally grandiose metamorphic processes. Ultimate polar opposing forces are revealed which, contemplated by us, demand an inner soul metamorphosis that can transform our relationship to the world. From the left to the right another quality of metamorphic process is catalysed by the presence of the central Being.

A late addition to the composition was necessitated by the need to bring about a visual balance. The Falling Lucifer figure had expanded in relation to the other figures during the enlargement process. This weight needed a balance on the left, and it inspired Rudolf Steiner to metamorphose rock into an elemental being of the rock. This offered a vital opportunity to awaken our consciousness of the elemental world and its intense interest in the destiny of mankind upon which its future depends.

A work of art is an act whereby the human being brings an element of life into material substance. It is through the existence of polarity that movement can be born; the balance of power and its continual readjustment in every aspect of the physical world demands it. Any form is the result of a process of movement at some stage in its genesis. Movement in the world of nature leads inevitably to rhythms and this can be universally observed especially in the realm of water. In art forms however we have to understand this and we need to work for it. Rhythms enhance the element of life, which as already noted forms the basis for an artistic work.

When Rudolf Steiner initially developed his own approach to carving over a period of some hours as work began on the interior of the Goetheanum building, he suggested a specific technique. He wanted the carving gouge to be used in such a way that while being conscious of the movement in the overall surface each cut should be made with a slight rotation, thus making a concave followed by a convex surface, a so-called double curvatured surface — this quality of surface is everywhere evident in living nature.

In the art of sculpture movement becomes fixed. Only the surface speaks to us and thus its very nature is of vital importance; it must continually remind us of the movement dynamic which brought about its genesis. We cannot imbue it with life but we have to come as close as possible to this condition.

Another dimension helpful within the realm of sculpture is rhythm. Rhythm is dependent upon a certain quality of repetitive process but one that is always changing. Indeed a mechanical repetition is unhelpful, as it no longer has any living dynamic within it. Rhythm in time may be manifest spatially as metamorphosis in sculptural form and this helps as we move about in our observations of the forms, reading as we go about the developments and transformations taking place.

Anatomical components such as head and limbs are only used here inasmuch as they can help us to latch onto something recognizable. Otherwise many would have been fearful of the power within form itself (this did gradually appear later through the experiments of many individual artists). Muscles and clothing are no longer entirely relevant: form is instead a vehicle for the expression of ideal or spiritual content. Remember this sculpture appears during 1916 when the public was still surrounded by naturalism in the realm of art.

The modern masters were only just beginning to appear and of course were very little known. They were about to educate us, after the end of the nineteenth century, into the secrets and reality of the nature of form and colour. Usually they are unfortunately referred to as abstract. However this is a complete misnomer. They are intent upon exploring and revealing the innate power and dynamic of form and colour itself — just the opposite to abstract (note the words of Brancusi and Kandinsky). By contrast it was the materialistic-naturalistic art of the nineteenth century that was deeply abstract and no longer related to life; it was almost entirely dependent upon copying nature and robbed it of its inner essence.

Rudolf Steiner was one of these new masters and intent upon bringing spiritual content into an understanding of form and colour, relating indeed to all the arts. Edith Maryon was one of few artists who recognized what was needed and she had the courage to be part of the major transition from the nineteenth century into the twentieth, through the end of the Kali Yuga. She dedicated the rest of her life to this task. It was the ending of this dark period and beginning of a new period of enlightenment that indeed awoke in a relatively small band of artists the need to explore new vistas of imagination. Gradually their work appeared, heralding a new era of creativity.

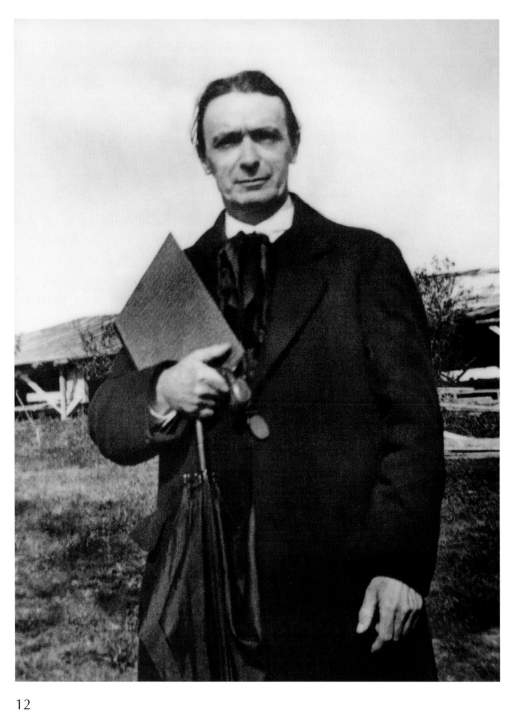

Rudolf Steiner on the building site, 1914

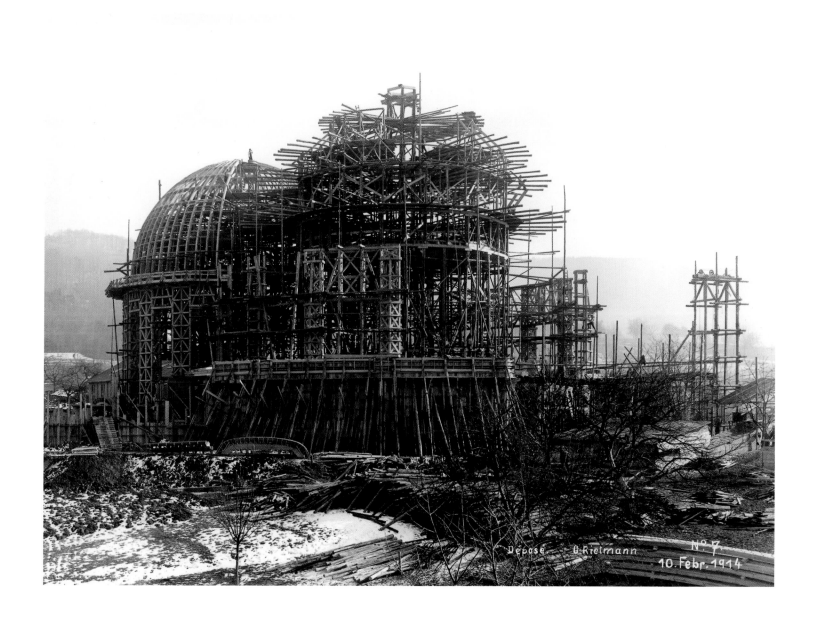

The First Goetheanum under construction, February 1914

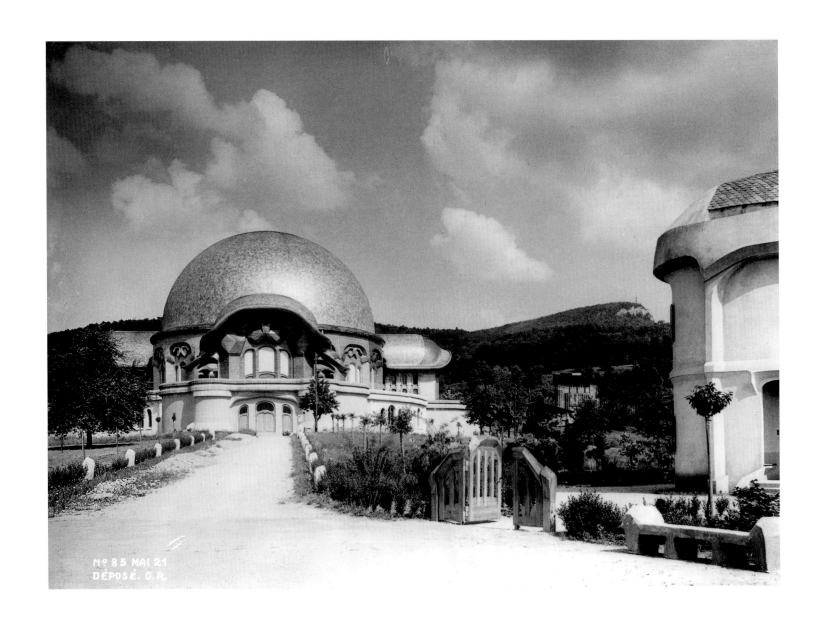

The First Goetheanum from the west — in the background on the right is the Hochatelier (the high ceilinged studio), 1921

The First Goetheanum

Judith von Halle

On 20 September 1913 there took place the laying of the foundation stone of the First Goetheanum, known at that time as the Johannes Bau. This was the beginning of a building project lasting over nine years, one that incorporated a quite different building conception than that of the Second Goetheanum. For the intention was to erect on the hill in Dornach — as a testimony of the secrets of world evolution and of mankind — the only visible imagination seen in the sense world of spiritual laws, which was to be brought down into the physical world and shaped by human hands.

And right up until 31 December 1922 this imagination, which had become sensory, did in fact continue to grow and develop in a unique way similar only to an initiation temple such as once existed in the ancient Mysteries. In such temples the great spiritual leaders of humankind had received their impulses. Now, however, it was as a place in which visitors were instructed in the Christian Mysteries. In walking through the inside of the building they were moving in a certain sense through the mysterious secrets of being human. For as they experienced the forms and colours designed according to supersensible conceptions they would bring themselves into an inner relationship with what they saw, and realize that the space seemed to be speaking to them in a particularly intimate way: the mighty pillars of the two cupolas, consisting of different kinds of wood, in which the capitals and architraves appeared in a wonderful way as though alive and in passing through

metamorphosis, were growing and separating out; the tall, strongly coloured windows with their different motifs; the cupolas themselves, elaborated with coloured paintings, a constantly moving interplay, backwards and forwards, right and left, up and down, through which the human souls moved and, either overcome in a flash by this evidence or feeling their way gradually, recognized their own image, their own path of development in what they saw — a place in which the world was grasped as a whole, both in space and time. An incomparable building, which, on the strength of both what it intended and was able to portray, could be compared to no architectural building or inner spatial design known up till then.

As pupils being initiated into the secrets of the workings of the universe, visitors learnt to know themselves as — seeing and experiencing it — they moved through the building sacred to the being of the cosmos and of man. As they went through the inside of the building the visitors could discover that the ground plans of the two interpenetrating circles and the domes arching over them resembled the path through their own bodily form, through the temple of their own body, which had come into being under the influence of planetary and cosmic forces. They learnt this from the pillars and their plinths, from the capitals and architraves of the large and small domed halls which gave evidence of the powerful forces of the divine beings connected with the seven planets and the twelve constellations. Mindful of

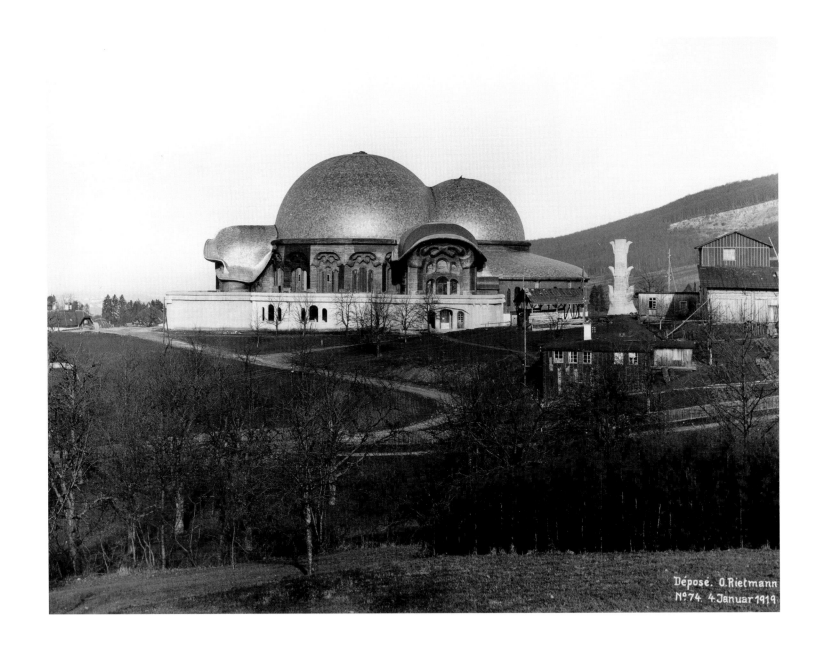

The First Goetheanum from the south — the Hochatelier on the right, in the background the chimney of the heating house — 1919

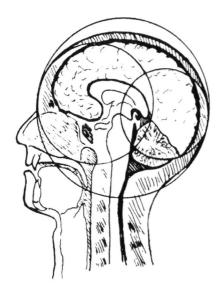

The double circle in the human head

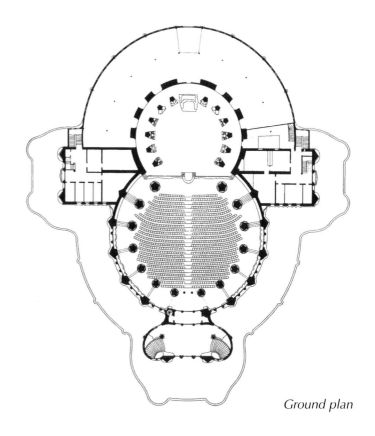

Ground plan

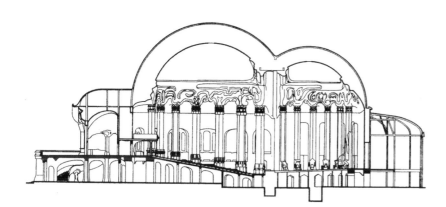

Cross section

17

Rudolf Steiner's reference to the fact that the form of every living human head is a metamorphosis of the trunk and limb organization of the previous incarnation,[1] the initiation pupils now experienced that the building presented the cyclic source of life of all that physical and spiritual existence was and would become. For, as an image of the human head with its cerebrum and cerebellum and the epiphysis placed between the two circles that one can think of as made up of the cerebrum and the cerebellum, and represented in the building in the form of the lectern as a threshold between the two halls, the building was just as much the outcome of a *previously* formed body as it was simultaneously giving the temple's proof of the *present* human body, which the temple was helping people to understand. So, as the temple of the body, the building also formed the foundation for the initiation pupils, by being able to read from it about their own bodily nature, to bring about the basic structure of a future metamorphosis of this body — the metamorphosis of the temple of the body into a temple of the spirit. In and by means of this building, its architecture, the wonders of the development taking place between the material and the spiritual nature of the human being could be experienced: the image of the head as the outcome of bodily becoming that takes place by means of divine influences; and the image of the body as a prerequisite for the head force that has to be developed by the conscious human being of the future — the recognizing, in their present selves, of the creative forces of the highest hierarchies at work on the human body as the metamorphosed thinking process of the future human being.

From the changing forms of the pillar capitals the people saw as they strode from west to east the truth that what is simple does not always end by becoming more and more complicated, but that a simple form passes through an intermediate stage of the greatest differentiation and arrives back at transformed simplicity, in the way Rudolf Steiner had described it in the words: 'That which is perfect is again simpler.' Using the language of the art of modelling this is referring to the temple construction of the future human being, which no longer had to be expressed in sense form with all manner of differentiated details, but ought to be built up out of building stones of simple spiritual truths and realities, joining together in harmony towards a complex spiritual structure.

In the engravings of the coloured glass windows visitors encountered the secrets of the human path of initiation, the interweaving of those two worlds between which human beings perpetually alternate — the material world during life on earth, and the spirit world during life after death, and also the pendulum swing between the two worlds during sleep consciousness. According to the position of the sun, the light coming in through the coloured windows glowed and shone in various strengths on the different mighty pillars that portrayed the planetary stages of evolution, enabling an ever-new understanding of the various aspects of the secrets of human evolution. When, for instance, the bright maple wood of the Jupiter pillar was bathed in the light falling through the last large south window in a delicate pink with its breath of the future, the soul arrived at quite a different experience than when the Saturn pillar in its hornbeam wood brought to living expression the prolific force of the origin of all the metamorphoses following on after it when the strong green light streamed in from the west through the first south window.

When the pupils' gaze then turned to the colour experience in the domes they took in how, by way of the creative exchange of the essential nature of red, yellow and blue, there arose in them the motifs of the course of man's evolution as an earthly being. Rudolf Steiner elucidated with

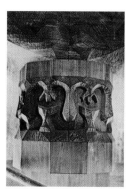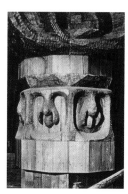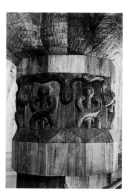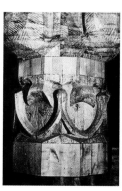

The pillar capitals from left to right: Saturn, Sun, Moon, Mars, Mercury, Jupiter, Venus — corresponding to the progressive movement in the hall from west to east

reference to the eighth scene of the first Mystery Drama that the world of colour represents a totality in itself, and that here it was not the colour being determined by the form — as otherwise happens when an artist separates the sea from the sky by a line dividing the two colours — but that, 'these forms appear as the creative work of the colour'.[2] And the pupils saw, there, human nature lighting up in the colour, showing how people lived in previous cultural epochs, and even further back, in times before the state of Paradise. When they took in the paintings in the small cupola their inner being followed the evolutionary progression up to their present human condition. They saw themselves as beings developing towards an 'I', as a kind of Faust figure living in the blue of clear thinking, standing between the child taking on form out of the warmth of the red and the dark, transitory skeletal man, before it — accompanied by the momentum in the architraves that carried them over the pillars of the small hall; they encountered abruptly the space at the extreme eastern point where the initiator of all these cosmic secrets would expect it to be: the reality and power of the Saviour within the dualistic forces of the adversaries prevailing in man's being.

Thus the pupils of initiation arrived at that place at which it was planned to place the completed wooden model of the Representative of Humankind, standing between Lucifer and Ahriman.

Constructing this building became possible on the one hand through the spiritual vision and spiritual knowledge of the great initiate and teacher of humanity Dr Rudolf Steiner, and on the other hand by means of the work of the hands of many ordinary people and many of his spiritually striving pupils.

Around three hundred people were engaged in the creation of this special building; among them were many voluntary, unpaid helpers. For this reason alone the First Goetheanum may be seen as a special work of art, as it acquired the status, in an exemplary anachronistic way, of being an example of what Rudolf Steiner formulated a few years later in his 'Threefold Social Order' as one of the essential processes needed in present and future times: the work of each single person would become a spiritual and creative possession of the community which could never be renounced.

The attempt had to be made in the first place — in a few strokes — to present to our readers such a clear and vivid picture of the building that the feeling might come to life in them that was approximately what arose in the visitors to the First Goetheanum when they took in, with opened eyes of the heart, the cosmic secrets that had been brought down into the sense world, and they brought the harmonies of these secrets to the point of resounding in themselves by applying a vision that calls forth a response as of a spiritual bow gently stroking the pillars and all the other secrets as though playing on the strings of a spiritual harp — this was a feeling of reverence, the deepest reverence for the indescribable beauty of spiritual wisdom and truth.

If this reverence can now re-echo in our soul, we shall for the first time be ready to come with the right mood for seeing the 'Group'. For this was the very heart of the Dornach Mystery temple.

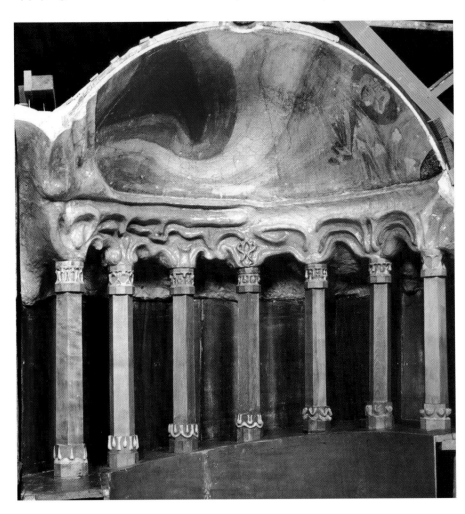

Original model, section: the large hall with pillars and metamorphosing plinths, capitals and architraves

During the erecting of the capitals onto the pillar shafts of the large hall, May 1914

Green window in the south

Blue window in the south

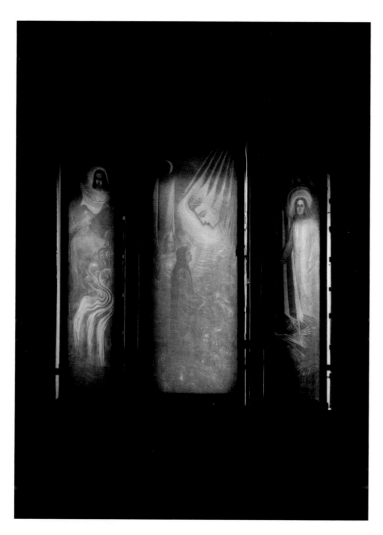

Pink window in the north
in the workshop of the 'Glass House'

Red west window
in the workshop of the 'Glass House'

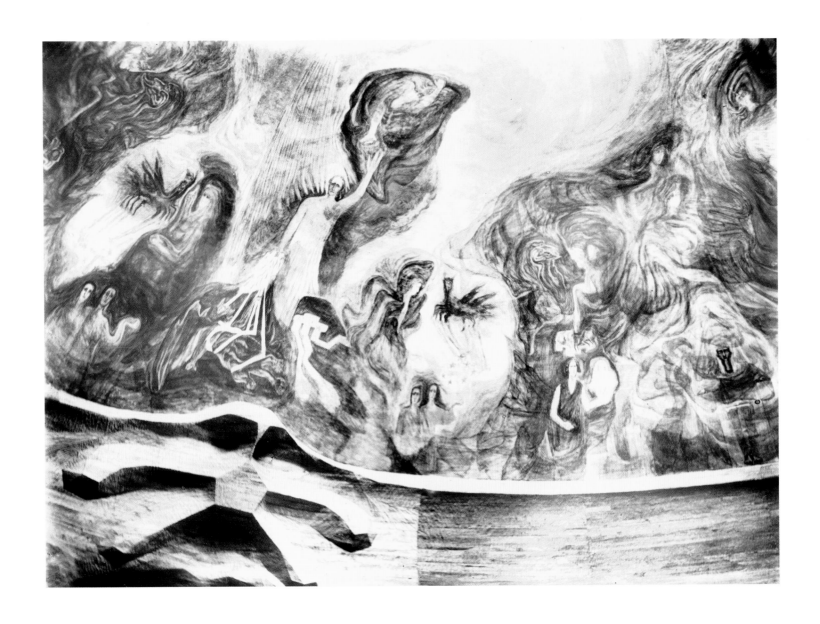

The dome painting in the small hall with the central motif of the Christ figure above the last central motif of the architrave — beneath which the wooden carving was to be placed

24

The plinth of the Saturn pillar in the light of the green south window seen through the provisional west entrance (Pastel sketch by Wilfred Norton.)

25

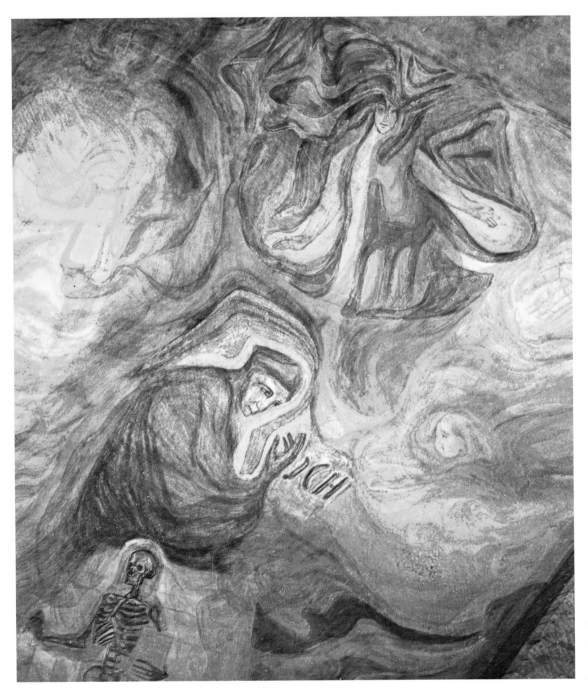

The 'Faust motif' in the dome of the small hall as the human being of the present, with the word 'I' — the only word appearing in the building

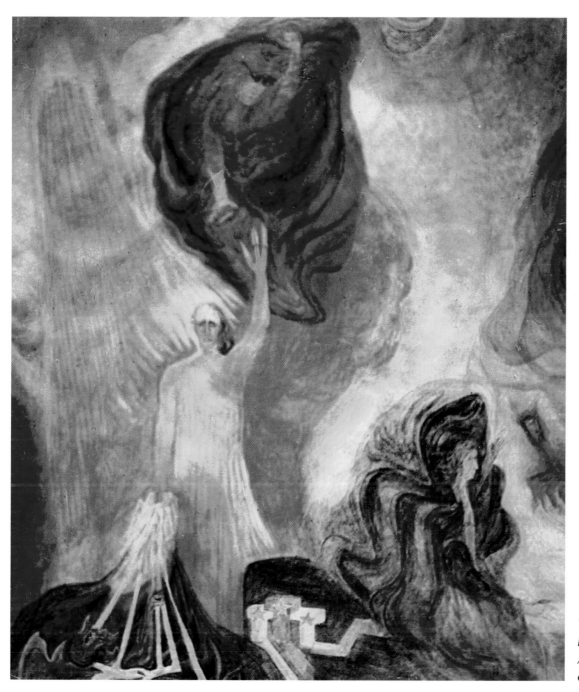

*The figure of the Redeemer,
between Lucifer (above) and
Ahriman (below), in the dome
of the small hall*

27

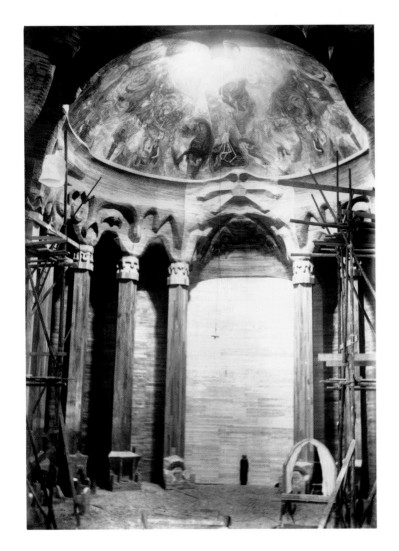

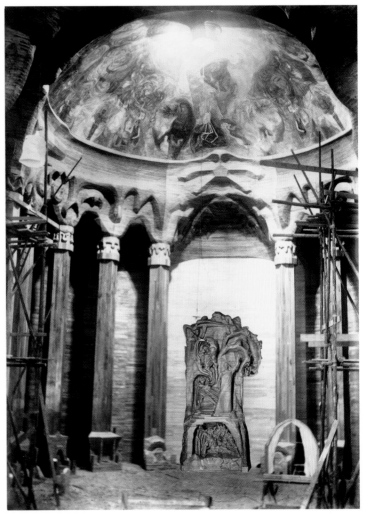

View of the hall containing the stage (the small hall) with the space for the wooden model in the middle between the pillars and the thronelike seats (about 1919)

View of the stage area with the carving in the centre (photo montage)

28

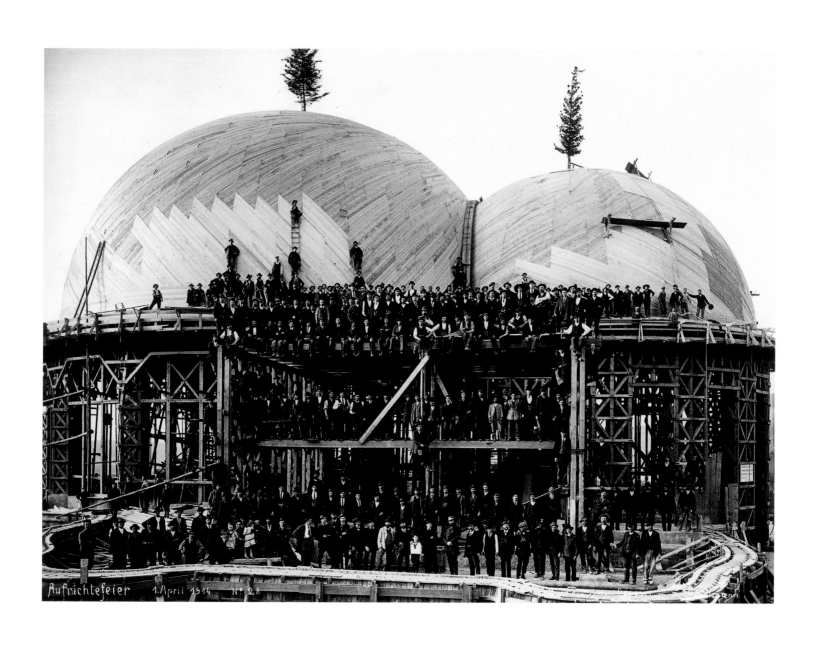

The topping out ceremony, April 1914

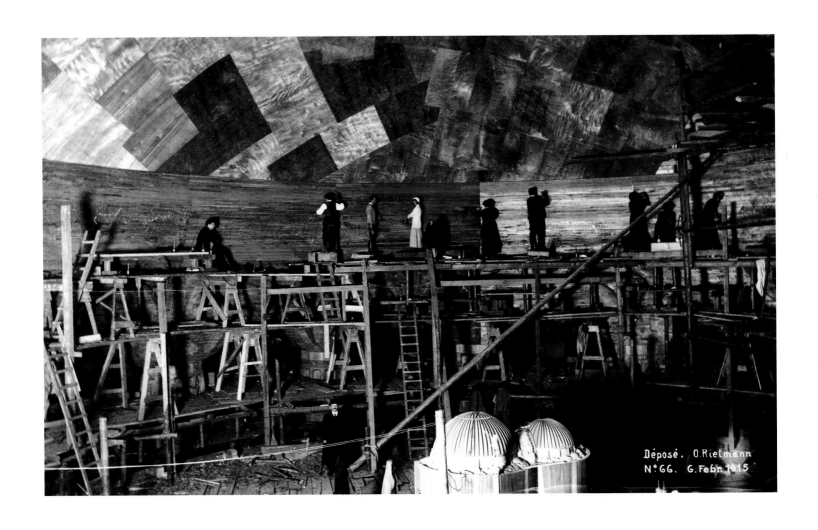

Work on the scaffolding in the large hall
The view to the north, February 1915

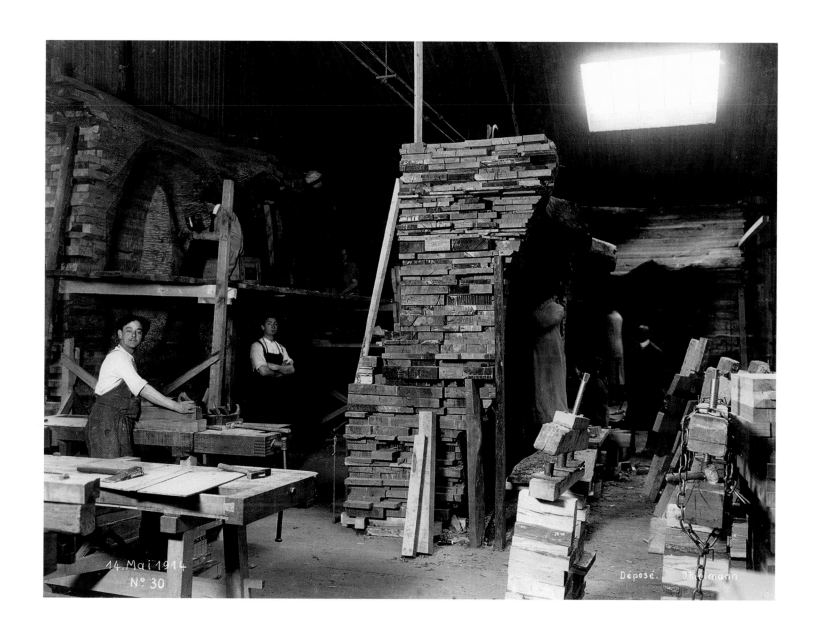

The gluing together of the wooden planks for the architraves and carving activity in the workshop, May 1914

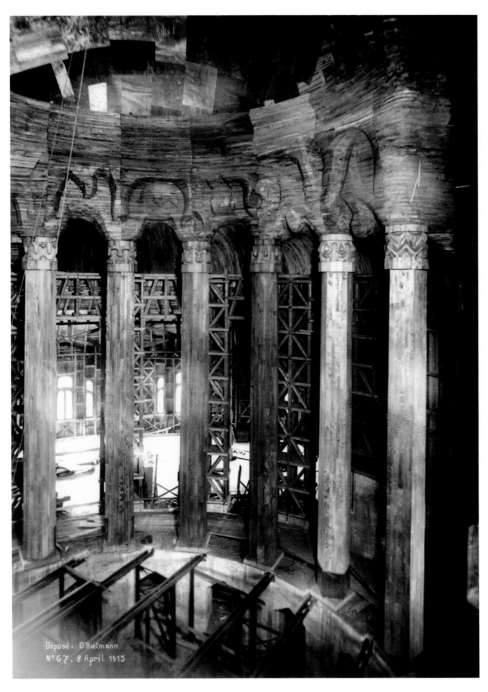

Déposé · O Rietmann
N° 67. 8.April 1915

View of the small hall facing south, April 1915

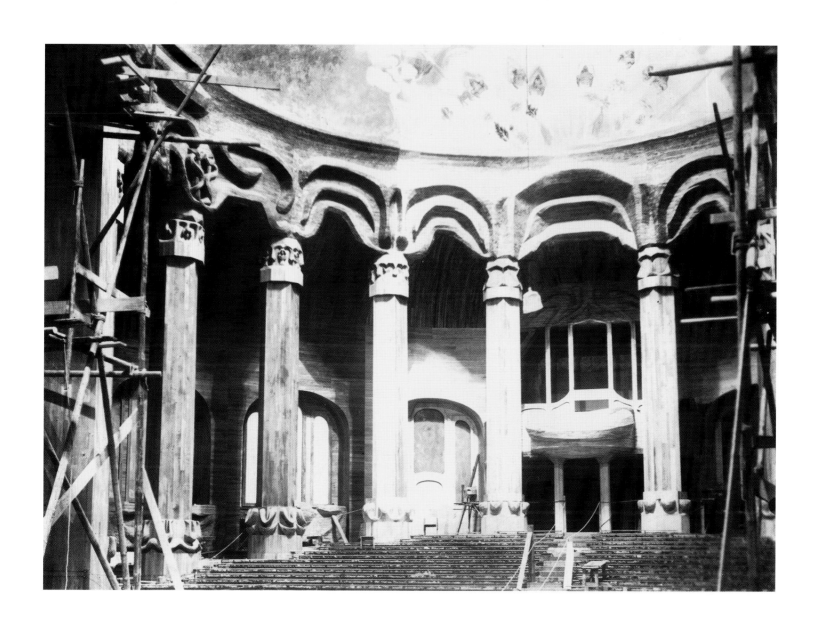

View of the large hall facing west with the organ gallery

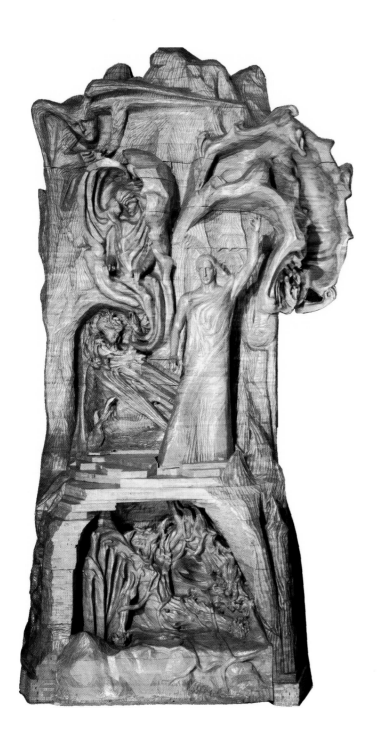

The Wooden Model

The Representative of Humanity between Lucifer and Ahriman, also called 'the Group'

Judith von Halle

Everything that had found real expression in the art work of the Goetheanum by way of its architecture, the forming of its inner space, the motifs of the coloured windows, the 28 pillars with their metamorphosing capitals and architraves, as well as the motifs of the cupola paintings culminated in the 9.5 m high wooden model of the Representative of Humanity between Lucifer and Ahriman, which was intended for the most eastern point of the smaller domed hall as the heart of the whole building.

By means of all that this building represented, by walking through it people could have had a feeling for the evolving world processes — in the way that, in the form of the body of the earth, it constantly went through transformation, and how higher spiritual beings accompanied and influenced this with their active engagement. One would have had the opportunity to experience earlier and more recent historical epochs of human evolving. With their hearts and their spiritual forces people would have been able to feel and understand the way man had once lived as a purely spiritual being in spiritual realms, realms that are, where our day consciousness is concerned, largely unknown to us today; how humanity slowly became condensed into physical-material form, and the path human beings had followed in order to separate from their natural connection to their spiritual home, so that they might to a large extent become beings with independence and self-knowledge.

The visitors went through all this within themselves: a review in spirit of the tremendous evolutionary secrets of our world, as taught and known in the Mystery Schools since the beginning of time. These secrets had now taken on visible artistic form, and were portrayed physically within the Goetheanum building. This made the Goetheanum a new Mystery temple, a temple in which human beings could find themselves and their connection to world evolution.

The time had come for this temple to become visible to the eyes of everyone in the outside world — not only to the eyes of Mystery pupils, as once was the case. Since the fifteenth century, the Renaissance, the age of the consciousness soul had begun. Human beings became conscious of their souls in a new way, meaning that they developed a member of their being that enabled them to observe their own soul, in fact all their soul processes, at a higher level of consciousness. This made them mature enough to realize that the things they could grasp with all their physical senses with regard to the outer material world, however much they could become master of this, neither explained their own being nor brought them to further development on a higher level.

The time had come when human beings could become conscious of the all-important process in world and human evolution: they had the spiritual strength to grasp what it meant that almost two thousand years ago the Mystery of Golgotha had taken place — the incarnation of God on earth. They could now learn to understand that this deed of God had been an offering of love to humanity. Through His

resurrection the Christ had awakened in man's inner being a slumbering seed, which the humanity of today had developed further and further: the 'I'. It is solely by means of their 'I' that human beings can grow conscious enough of themselves that they can break free of all bondage, that they can exist as beings able to decide for themselves and take responsibility for themselves and their actions.

This 'I', the highest member of the human being, was on Good Friday represented in Christ. In the course of Good Friday and Holy Saturday of the turning point of time, on behalf of all human egos it went through the depths of death. It had been victorious over the death of the physical body. And its very strength, everything at the disposal of this 'I', was displayed in Christ's resurrection. For on Easter morning there arose not only this 'I' as a spiritual entity, but it was able to form a new physical body in which the Risen One could be seen by his disciples, by the women who had been round Him, and even by Paul. This physical body was not of a material nature but was spiritualized, ennobled to the highest degree. This 'I' had passed though every imaginable trial, had withstood the temptations by the adversaries, and had transformed the lower members of human nature, such as the materialized physical body, into forms no longer material.

This resurrection body of Christ was like a mighty and unique token for humanity of what the 'I' is able to achieve, when it then becomes active in human beings and remembers once more its spiritual home. This work of creating a purified bodily nature has, since that time, been able to take place in every single human being. Depending on particular conditions, human beings will, over the course of many lives, bring to being a similar spiritualized body to the one the Christ raised up at the turning point of time in three days. This was contained in Christ's prophecy to the scribes, that 'in three days he would raise up the temple' (John 2: 19). He was speaking of the temple of the human body in which the new, divine bodily member — the 'I' — is able to dwell, a 'house' that will exist beyond the death of the physical body, beyond the material death of the earth.

Human beings can now come to know that this 'I' — as it is now able to purify and sort out all the bodily and soul occurrences and disorders in their inner being — is the gift of Christ, is the essence of Christianity. Ever since the resurrection at the turning point of time human beings have within them this Christ seed; and today — in these times when forces of consciousness have awakened in us — we can bring it to life the moment we become aware of it as the force of the Christ in us. This fact of knowing inevitably involves moral action. Human beings begin to become higher beings. And this involves working to create the kind of temple of their body in which the Christ had already clad Himself by Easter morning.

A bodily form such as this could not be created purely by spiritual 'magic' but only through the incarnation of God, a divine being. This meant the descending to earth of this divine 'I' and of its entering into a mortal human body in which it also went through physical death. Having done this, this 'I' could make genuine forms in the resurrection body. A material form would once have had to exist, however, to create its spiritual image.

In the last chapter it will be seen that this way of becoming also holds good for the forms and content of the First Goetheanum.

Ever since the turning point of time human beings have had before their eyes this goal of developing further and further towards becoming a moral, divine being. By the grace of their Saviour's sacrifice they can attain this goal independently; and *their own* sacrifice will consist in letting go of everything that tries to prevent them from pursuing this path back to their spiritual home. Even Jesus Christ was

tested and tempted. Now and then it will appear to human beings that it is a great sacrifice to let go of everything that seems to them to be so comfortable and easy in this material world. They will require many lives to reach their goal. But at their side there will constantly be the help of the Christ in that He became the archetypal picture of achieving, for all time, the crowning point of all sacrifices.

Christ is the 'Representative of Humanity' in the sense that He has an endless capacity to sacrifice Himself along the path of ennobling man's true being.

As visitors move through the building from the western entrance, and their eyes, their attention, arrive at what was expressed through the central model in the east, they had inwardly come to Golgotha, meaning they had finally come to themselves.

Thinking in this way, Rudolf Steiner said in December 1919: 'If destiny so wills, and this building can ever be completed, the people sitting in it will, as it were — seeing directly in front of their eyes the Being who gave earth evolution its meaning — feel the urge to utter the words: the Christ Being. But this has to be felt in an artistic way. It must not merely be thought of intellectually in some weird and wonderful way. But it has to be felt. The whole of it has been conceived artistically, and the most important thing about it is what comes to expression artistically in the forms. Nevertheless it is essential that entirely out of the feelings — that is, excluding the intellect altogether, for that is meant to be only the means of reaching feeling — people shall be urged to look towards the east and be able to say: "That is You." '[3]

A fundamental understanding of the wooden group is based on knowledge of the duality of the adversary powers. If we were to start from supposing that human beings, on their path to higher development, were to encounter only *one* 'devil', we would not only have misunderstood the

Rudolf Steiner — January 1919

nature of the members of our being but we would also not be able to understand and imitate the healing process that the Ego Force of the Christ is activating in human beings, and has been made visible in the wooden model.

37

Anthroposophy shows us what an initiate or clairvoyant has always perceived: man in earthly life has a totality of four different parts to his being. One is the material body — the skeletal man. It is observable that this material body can never be perceived by itself, for as long as a person lives this body is interpenetrated by three other members. The 'I' especially, which makes each of us human beings into an absolutely individual being, forms a considerable part of our physical-material appearance. Not until the moment of death, when our higher members actually leave our body, do man's merely material remains lie there — and we get a picture of the perishable skeletal man as such.

As second member there is, during earth life, a body of formative forces called the etheric body that is invisible to our physical eyes, and without which the physical, material body would remain lifeless. Without it there would only be the skeletal man, in the same way as a stone differs from a plant. Unlike stones, plants possess over and above their material existence a living quality conferred on them by their etheric member. They draw their life forces from the ether, and it is this that makes them into beings that grow and wither.

The third member in the human being is the astral body. Human beings receive astral forces from the encircling stars. These forces make them into feeling beings, and this quality man shares with animals. By having an astral body, a soul, both human beings and animals can feel pain, well-being and other nuances of soul life. Human beings have in the course of time, in contrast to the animals, developed over the millennia various differentiated soul qualities.[4] The more extensive their feelings have become, however, all the more severe have the attacks on their soul welfare become.

The fourth member belongs to man alone (if we disregard for the time being the higher spiritual hierarchies). It has the particular quality of being able to bring the lower members into a certain state of harmony. Having this fourth member of their being, the 'I', humans have become conscious beings who now bear full responsibility for their thinking, feeling and will.

This spiritual nature of man — the way it appears on earth with all its inner contradictions and battles — we rediscover in the wooden model. It does of course portray for us all that represents humanity engaged in higher development: the Christ. So one gets the impression of the condition arising when the human being stands up firmly to the temptations and opposition attacking him from outside and raging within. It shows an upright human being, moving forward, as distinct from cowering in fear or entirely involved in himself.

The first thing viewers will see when they look at the wooden model will be the 'Representative of Humanity'. The form of the central figure does not comply with the traditional representations of the Saviour as presented in the history of art. Just as this particular manifestation is not intended to be like any sacred model of Jesus, neither did Rudolf Steiner use the term 'Christ statue' for this, nor actually for the whole Group. This brings us to a distinct characteristic of this artistic work of art. A 'static' model is just what it is not. It is also not a modelled presentation of an instantaneous picture of a particular movement or situation, but a living testimony of man in the present and the future, and also his archetype, the Christ, constantly engaged in movement, bringing about a balance between the two adversary powers.

Rudolf Steiner and Edith Maryon created in this modelled group something that had never existed before in the realm of art. Those powers who do their mischief in man's spiri-

tual members, the etheric and the astral body, are — like their own activity zones — invisible to the physical eye. Rudolf Steiner, however, with his spiritual capacities could, beyond the threshold to the sense world, take into himself a picture of the nature and characteristics of the two 'devils' Lucifer and Ahriman, and the gestures arising in them, and imitate them on this side of the threshold. Therefore a creative process had to be set in motion that had never before been carried out in the Christian art of modelling: spiritual beings, with their own unique characteristics, had to be transferred into the sense-perceptible nature of the art of modelling. This 'transferring' had to be taken literally, because in the process of being portrayed the adversary powers were also being unmasked to people without clairvoyant vision. The worst one can do to these adversary powers, from their perspective, is to make them and their plans visible; for those people who get to know their characteristics and intentions can all the more easily defend themselves against them, and will not so readily fall for their temptations.

With the implementing of these artistic plans something happened which, though intended by Rudolf Steiner, presented people's everyday level of human feeling and understanding with a real challenge. By transferring the qualities and gestures of these spiritual beings something was created that was far more than their 'image'. In having their images modelled they had actually to present themselves. This made the 'Group' into a truly living work of art. Those who approach it particularly attentively will be able to perceive the direct presence of the spiritual beings in the modelled figures. On the basis of this fact people will, through and in the 'Group' itself, be able to find themselves again as soon as they begin to listen to the way Lucifer and Ahriman, in their modelled images, enter with their purely spiritual being into communication, as an echo, within their own inner human being; whereupon they will have a feeling experience of the way the Christ Being places Himself with moral strength in a beautiful way between them.

Therefore the modelled forms of the wooden 'Group' come directly from the actual realities existing in the spiritual sphere and not from the life of the artist's imagination or from the observation of external nature.

Right from the first viewing of these two figures, both those below and above, and those beside the middle figure, the viewer has the experience of a tremendous contrast existing between them. The only point in which they resemble one another is in their vain desire to grab hold of and take possession of man.

One of them is an ossified creature with clenched, clawlike fists and a face like a petrified grimace. It is the real picture of Ahriman. Ill will, hatred, malice and dishonesty are some of the characteristic features of this adversary. Ahriman influences the second member of man's being. He works in the etheric body, which intervenes in the physical, material processes. But these also happen to be the home of the temperaments and habits, which become like second nature to us. We find it very difficult to influence our temperament or our habits, for these are firmly embedded or actually written into the etheric body. It requires hard training in self-discipline to rid the etheric body of bad habits, as for instance alcoholism. Ahriman wants to do his utmost to influence human etheric bodies to such an extent that human beings cannot spiritualize their members. Human habits should become so firmly entrenched that they will become visible one day even in the physical body, so that human beings grow to identify themselves to such an extent with matter that they lose their higher spiritual forces.

To turn to the other one: in the two voluminously formed upper figures we see the real picture of Lucifer. As his name

indicates, Lucifer is a kind of light bearer. In total contrast to Ahriman he has the intention of dazzling human beings and tearing them away from incarnation into his spiritual heights. Whilst doing so he overlooks the fact that human beings need life on earth for their development. Lucifer wants to whisper to them all the time that they should let go of life, that they are mature enough to aspire to the spiritual realm without having gradually to form for themselves ever-new earth lives — often by way of a difficult destiny, but one that would bring real progress. Lucifer relates to the third member of our being, the astral body. He influences man's soul life. Excessive self-love and overvaluing oneself are two of his characteristic features.

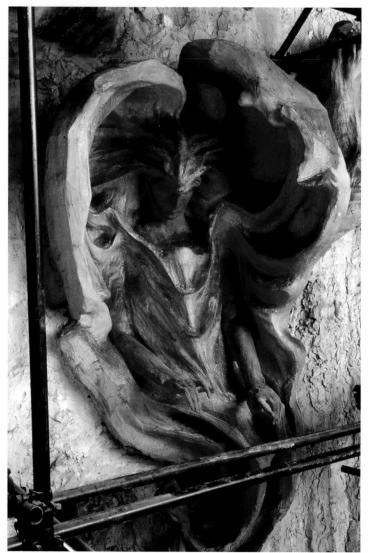

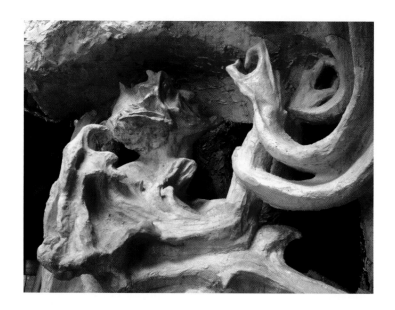

Every day, in their earthly life, human beings exist in the realm of tension between these two powers. And they would be excessively torn between these two poles, unable to come to an inner balance if a third, ordering force were not to place itself between them: the true light-bringer of the fourth member of the human being, the 'I', of whom in olden times it was said 'Christ, the true Lucifer'.[5] For the light that the Christ brings is not cold and dazzling, but He is the warming light of knowledge and love. In Him the beings of Lucifer and Ahriman are kept in redeemed har-

mony. He brings them into balance, whilst on their own they can only go to extremes and assume therefore destructive forms of members of man's being.

To begin with Rudolf Steiner and Edith Maryon intended there to be a triad: the modelled presentation of the Representative of Humanity as the Redeemer between Lucifer, who is falling from the heights of heaven, and Ahriman, who is condemned to the depths of the earth. (This is recognizable in the course of the following chapter in the series of plasticine models, which preceded the final presentation in wood.) We can picture that the figure of the Christ was thought of as announcing the future state of human beings when they have overcome the adversary powers. You have to imagine the Representative of Humanity in a pronounced diagonal, with His left arm pointing upwards, whereupon Lucifer breaks his wings and plunges down headlong from the pinnacle of self-over-estimation, and His right arm directed downwards, warding off Ahriman's deadly attacks so that the latter enchains himself in the earth's veins of gold and is confined in his cave.

This does not mean at all that the Christ Being has to be understood as destroying the adversary powers. The chief theme of the 'Group' was, and is: the Representative of Humanity as the Redeemer. Not destruction but balance. Although Lucifer's and Ahriman's endeavours have to be held in check, in order for them to be redeemed the decisive deed is the redemption itself. Checking them is only instrumental to their redemption. Therefore, in the earlier stages of the Group the arm, hand and finger positions of the Representative of Humanity go through crucial changes. While in the earlier models of Rudolf Steiner's, and particularly those of Edith Maryon (see illustration on p. 58, pictures 1 and 2), the arms of the central figure point

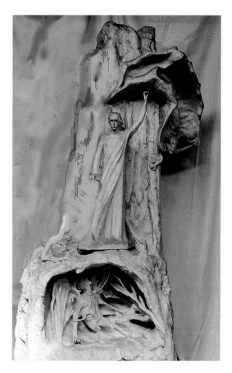

Triad: Lucifer, Christ, Ahriman. The 2 metre model in its initial stages. Photographic reconstruction

absolutely straight upwards and downwards with a posture that rejects the falling Lucifer and holds down the crouching Ahriman (see illustration on p. 58, picture 3), we have, in the wooden version, the impression that the gently bending arms and the bent fingers keep control over the two adversary beings as though holding them with reins while at the same time drawing them lovingly towards Himself — a solemn gesture, yet an act of pure love.

This triad, however, would only be presenting the condition of future man, namely the higher human being in which the Christ 'I' prevails to the point where the fallen brothers, Lucifer and Ahriman, lose their destructive powers and within the human being itself can rise to their own human level — that is, become redeemed by the overcoming of their bad qualities.

Rudolf Steiner finally took up once more the theme of the

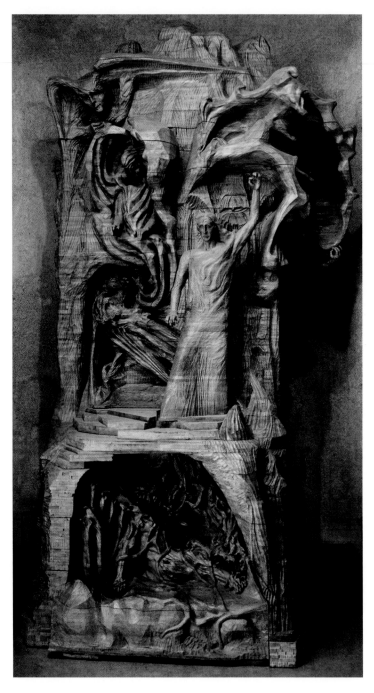

fallen brothers of Christ in another way in that he modelled Lucifer and Ahriman a second time and added them *beside* their noble brother, the Representative of Humanity. This emphasizes the inner strife and extremity of this duality, placed there beside the balanced figure of the Redeemer. It is this arrangement that first brings to full expression the salutary, edifying presence of the central figure. It is just this duplicity of the portrayed adversary powers that brings home to the observer the urgent need of the presence of the Christ in man's inner being. Beside the duo of the falling Lucifer we see above and the Ahriman in his cave below, it is just the sight of the two powers in combination with the Christ that shows us the actual *current* situation existing in people of today. Here, the adversaries are not yet over-come, but present their characteristic being in the way they can affect people of today: Lucifer forcing his way upwards, enclosing himself in self-love within his own wings; Ahri-man in his cramped and hate-filled posture in his efforts to pull everything down into the earthly realm. Without the purifying ego force the two adversaries are not yet over-come, in fact they show themselves in their true reality. They even hook themselves onto one another. They are demonstrating the split caused in man in the way they pull him, now upwards now downwards, but hooked together, so that human beings do not get away from them but are condemned to be at the beck and call of their designs, However, when the ego force of the central figure begins to take effect in that human beings turn to the reality of the spiritual world and to working on themselves, that state of being that is expressed in the original triad grows stronger and stronger within them.

By having placed Lucifer and Ahriman once again *beside* the Redeemer it makes it apparent where the chief focal points of their influence are: Lucifer hovers at the level of the head and chest organization of the central figure,

whereas Ahriman squats in the region of the lower man and the limb organization.

The forms Lucifer produces through his spiritual gestures resemble tremendous earlike wings, growing out of his chest and head. In falling, Lucifer is on the way to his redemption; the back of his head even becomes trans-

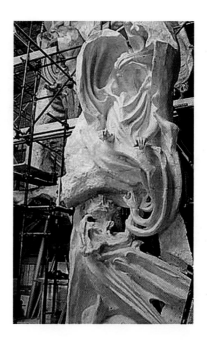

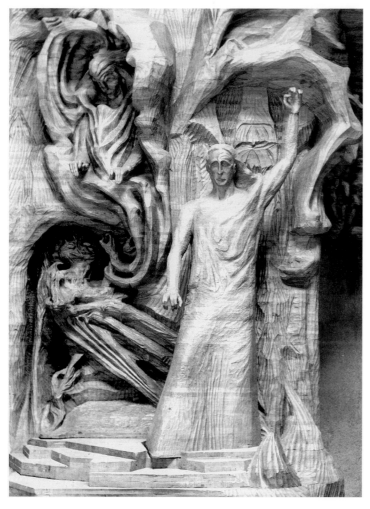

The Christ beside His brothers. Portrayal of man's current inner being

formed into a form similar to a human ear. Lucifer wants to draw up into man's head organization everything that actually belongs to the middle part. He wants to take away from human beings their connectedness, their indebtedness to the earth. Therefore Lucifer does not touch the earth. He has no legs, no feet. All one recognizes is merely an appendage of a limb organization that tried to form earlier on and now belongs more to the chest, and with this he tries to wind himself round the clenched fist of Ahriman in order to pull him also up into the heights.

As is also the case with the adversary powers after they have been *overcome,* the essential being of Lucifer is also emphasized by the art of sculpture in that on the one hand he forms concave shapes by way of his wings, yet also appears to be separating from the Group. He is dissolving out of matter. His wings enclose cavities — he is trying to become a cavity himself. He wants to tear himself away from being moulded, and to fly away. On the other hand

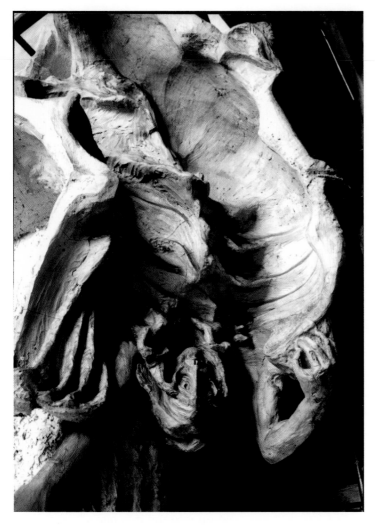

Lucifer falling

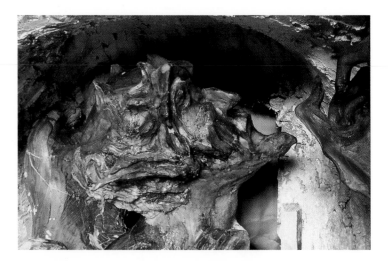

Head of the upper Ahriman

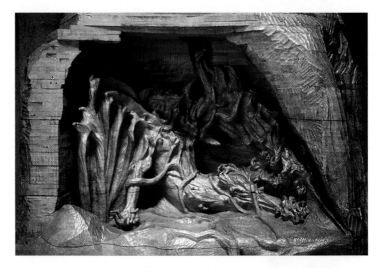

Ahriman in the cave

Ahriman is virtually burying himself in matter. He himself is becoming materially glutinous to a high degree, contracting and hardening. His wings are ossified; he is incapable of detaching himself from the Earth. His appearance had to be expressed in a more and more complicated use of the convexity of the wood. The lower Ahriman appears har-

dened to such an extent that he seems virtually to have buried himself in his cave. He is even stamping his silhouette, his shadow, onto the cave. Therefore his dwelling place becomes concave. In the making of the figures and their surroundings care was taken that the volume com-

44

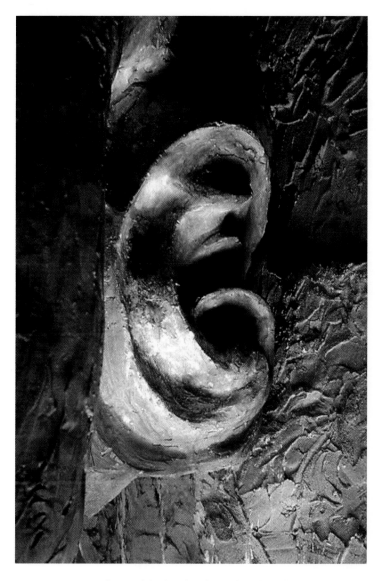

The earlike back of Lucifer's head

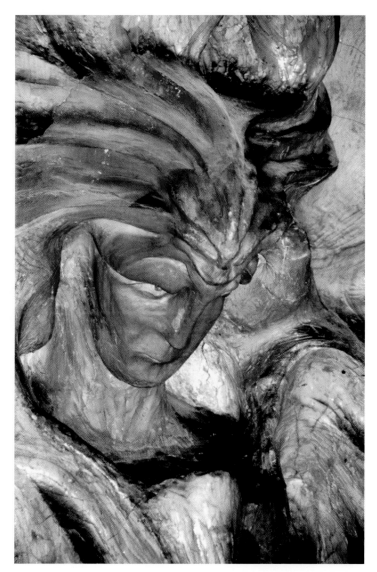

The upward-striving Lucifer with his eyes looking downwards

prising Ahriman's cave becomes released by Lucifer in the exaggerated forms of his wings.

If one's gaze now returns to comparing the positions Lucifer and Ahriman are in compared to that of the figure of the Redeemer, one realizes that the upper Ahriman — compared to the Lucifer who is striving upwards — reaches only to the chest organization of the Redeemer. His gesture shows that he, too, still desires to continue to pull down

45

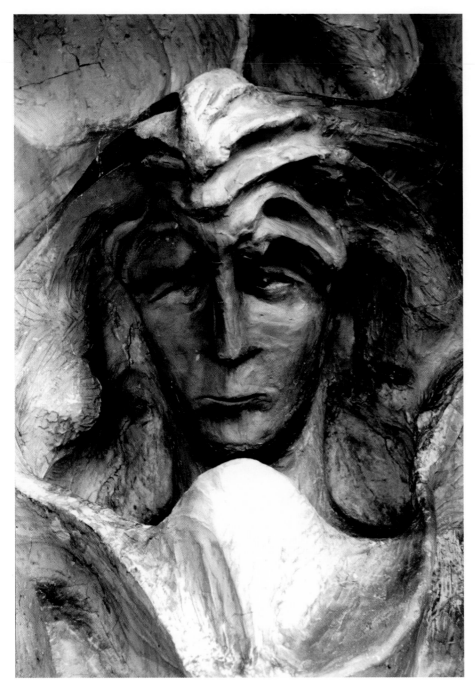

Lucifer, seen head-on, from below. Both Lucifer and Ahriman look into realms that they cannot reach

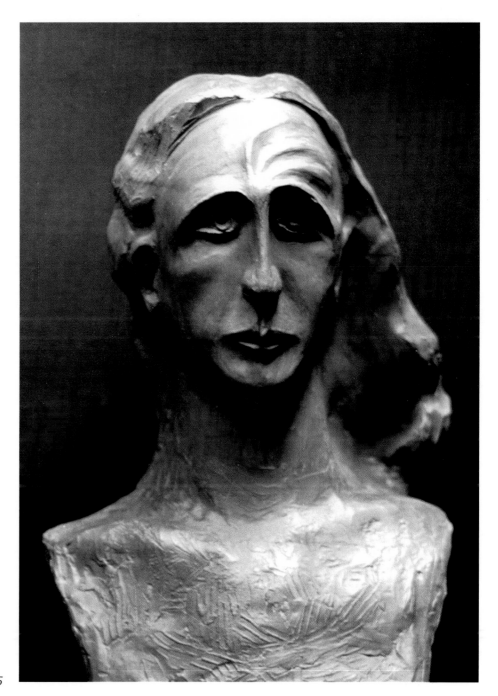

Easter, April 1915

everything that is at his level. This hardening force is manifest in his contorted face and in the way his lower limbs are growing together with the earth, which is also clearly recognizable in the lower portrayal of Ahriman. His head is trying to rigidify and not be an image of the cosmic dome. The lower Ahriman's right hand is as though spastically ossified in a way that is both really tragic and provokes compassion. Whilst the upper Ahriman is still developing claws in order to drag down in his clutches all that is striving to become spiritual, the left claw of the lower Ahriman — the as it were 'redeemed' Ahriman — appears no longer to desire this. It appears as though from now on he is scraping at the roof of the earth prison in order to be able to reach his pure, divine brother.

In the way the figures are hooked together the tragedy of it is made particularly clear.

Whereas the one has the urge only to go upwards, in the case of the other it is only downwards. But in this lack of initiative there is also a tragic lack of ability to achieve, for each of these spirit beings is turning his face to that sphere which he cannot reach, and does so in his own characteristic way: Ahriman displays tensed, even soulless facial features; Lucifer, incapable of observing another being, is so entangled in self-love that it is seen in his inward-looking gaze, which is squinting slightly.

In this way the actual beings of these two powers, resident and active only in the spirit sphere, were made visible to the senses by being shaped artistically. And this had also to apply in the same way to the Representative of Humanity. He had also to be modelled in such a manner that His mighty spiritual essence could enter in its true artistic likeness. This necessitated a fully comprehensive knowledge of the Being of the Christ, something of which undoubtedly Rudolf Steiner alone was capable. Already in May 1912 Rudolf Steiner had, in a lecture in Cologne, given a verbal description of the form and characteristic features of the central figure, in fact in exactly the same way as it was later realized in the wooden model. That was just two years before he and Edith Maryon began to make the first drawn and modelled sketches of the 'Group'. The precise way in which the spectacle of the Representative of Humanity stood before Rudolf Steiner's eyes is seen in an excerpt from the words he used in the Cologne lecture:

'When, after having concerned oneself deeply with this spiritual-scientific approach to the Christ Being, the time comes when one will endeavour to portray the Christ. One will obtain a figure in whose countenance one recognizes something that every branch of art must and will struggle to attain: there will be something in His face of the victory of the forces, in the face alone, over all the other forces of the human form. When human beings will be able to form an eye, alive and filled solely with compassion, a mouth not meant for eating but only for speaking such words of truth that come from the conscience on the tip of the tongue, and when a forehead can be formed that is not a beautiful, high forehead but is beautiful in its clear formulation of a tension focusing towards what one calls the lotus flower between the eyes — if all this can at some time be portrayed, then we shall be on the way to having found what the prophet foretold: He hath no form nor comeliness. This means not beauty but that which will be victorious over decomposition: a figure of Christ that is all compassion, all love, all conscientious duty.'[6]

These words portray the countenance that rays out to us from the Representative of Humanity. From the chest and the spiritualized garment a Trinitarian ray passes over to the Redeemer's forehead. Wonder, compassion and love as well as conscience ray out of the region of Christ's heart and are stamped on His countenance. These are the keys to the redemption of the adversaries.

In the same lectures, Rudolf Steiner tells us about the

great extent to which the life of a human being and Christ's own life is connected: 'The Christ Impulse unites itself with individual human souls to the extent that in their souls human beings can feel wonder for world secrets. The Christ is gathering His astral body from out of world evolution, from out of all the feelings that have come alive as wonder in individual souls. And secondly, what human souls have to develop in order to draw Christ towards them are all the feelings of compassion [...] compassion and love are the forces out of which the Christ will form His etheric body until the end of Earth evolution. [...] The third thing that enters into human souls, as though from a higher world, is conscience, one which human souls obey, one that they value above their own individual moral instincts. It is this to which the Christ becomes connected the closest: it is out of the impulses of conscience of individual human souls that Christ is gathering His physical body.'

This interplay between man and God could take place the moment people faced the completed central figure in the modelled 'Group' and took these words of Rudolf Steiner's into their consciousness.

In contrast to His fallen brothers the Redeemer's hair blows about. His whole head is in the region of the heavenly heights, yet with His firm tread he also connects with the body of the earth. His chest is formed as a link between what is above and what is below. This reveals the secret of the words: 'et incarnatus est'. God came to earth in human form, and the changing form of His resurrection body is forged out of the two components: the divine 'I' (the spiritual force) and the human body (the physical form). This makes Him totally different from Ahriman and Lucifer, who are imprisoned in their areas of activity, the only places where they are capable of dwelling. He is the figure, who, as it were, stands out from the scenery. He is walking, not standing still. He is walking forwards, towards human

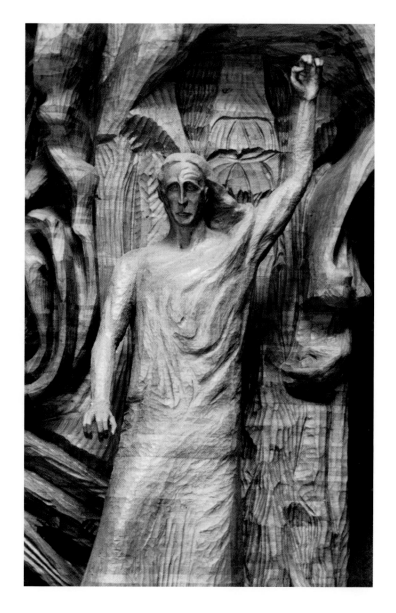

beings and their future, so that an observer becomes aware of the chief characteristic of the Redeemer, consisting, in complete contrast to the adversaries, in a constantly advancing evolution, and in Christ's words: 'I am with you

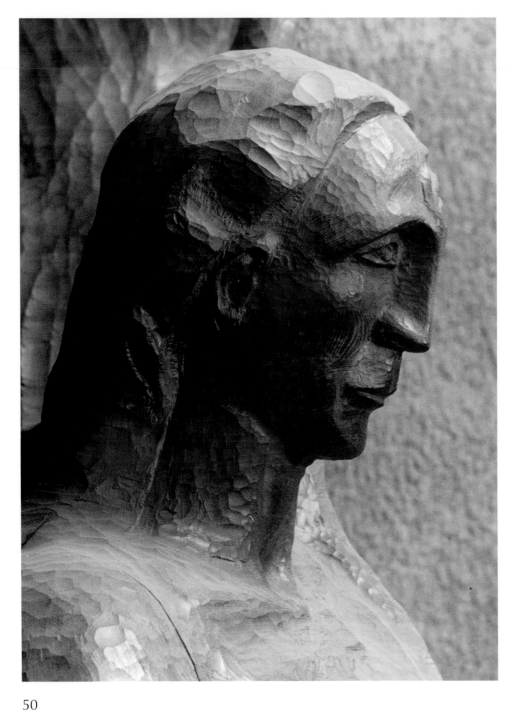

50

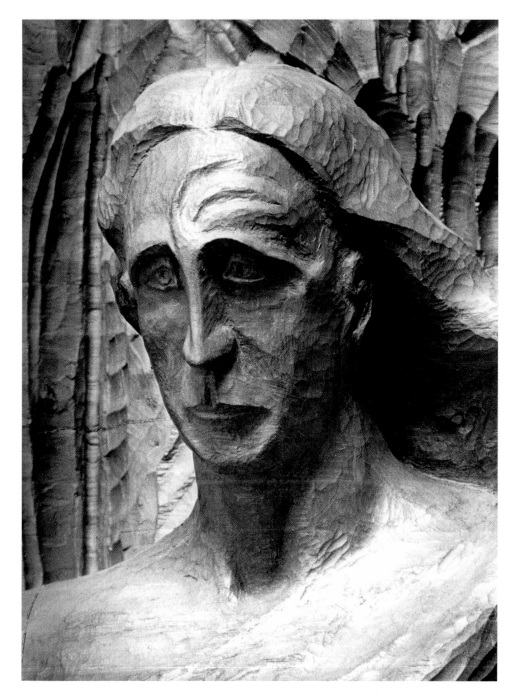

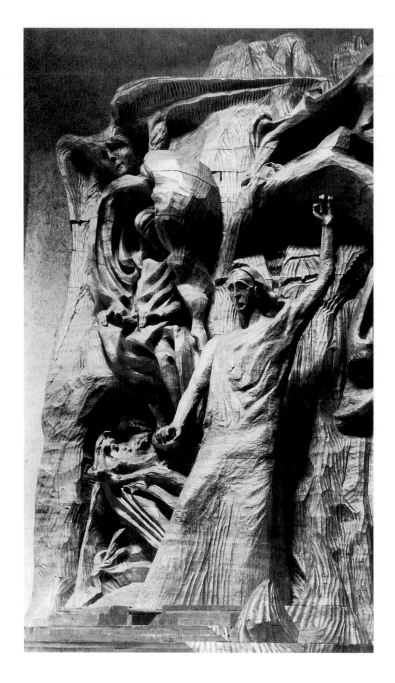

until the end of earth days.' With the formative ego force of the Christ earthly man will attain to this end of earth days.

A sixth figure has been added to the 'Group' that neither seems to represent anything to do with the nature of the Representative of Humanity nor that of Lucifer and Ahriman. From where an observer stands it is on the left upper corner of the model. Rudolf Steiner called it the 'being' or the 'rock being', for it virtually grows out of the rocky background of the 'Group'. It was not a part of the draft for the model right from the beginning. None of the stages of the model contain the rock being. It was subsequently added onto the last model as a sketch (Fig. 5 on p. 59). Its existence arose from two indirectly connected circumstances. In the autumn of 1916 the scaffolding, which had been erected in front of the 1:1 plasticine model in the tall studio specially built for it, was removed. For the first time they had a clear view of the relationships of the various figures during the setting up of the large model. On this occasion there was a small group of visitors in the studio, among others the Dutch painter Mieta Waller. She gave her frank opinion that the extremely expansive figure of the falling Lucifer on the right corner of the 'Group' brought an imbalance into the composition that gave an impression of it tipping over sideways. In the small models the asymmetry had not stood out so clearly, as Lucifer took up less space there than in the large model. Although Rudolf Steiner and Edith Maryon had actually intended from the beginning to include this asymmetry, on the day the visitors came they agreed that, as it was, it was overdone. And so, that night, Rudolf Steiner made the first sketch of the being that was intended to bring to life again in its facial features a reduced form of the asymmetry.

Barely four weeks after this incident a situation occurred on the newly erected scaffolding in front of the large model, which appeared to add to the outer optical reason an inner spiritual reason for including the rock being. Rudolf Steiner

52

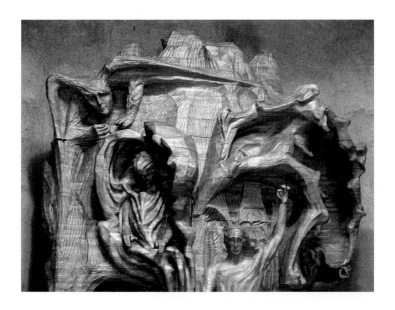

performed an arm movement in front of the upper falling figure of Lucifer in order to emphasize for Edith Maryon what he had been saying. Whilst doing this he almost fell from the scaffolding — in the same way as Lucifer was falling in the modelled presentation — but in the nick of time Edith Maryon prevented this happening. Both for Edith Maryon, to whom the life of her beloved teacher meant everything, as well as for Rudolf Steiner this event was a shock, and manifested yet again how potently the adversaries work in the physical world. The incident was taken so seriously that there was common agreement to keep quiet about it.

An event such as that, which was so serious that Rudolf Steiner himself eight years later, after the death of Edith Maryon, only hinted at it, required the presence of a being portraying cosmic humour to be added to the wooden 'Group' both for spiritual reasons and sensory reasons. In a lecture given in July 1918 Rudolf Steiner said about this 'Cosmic Humour', as he now called the being:

'This gesture of looking down with humour over the

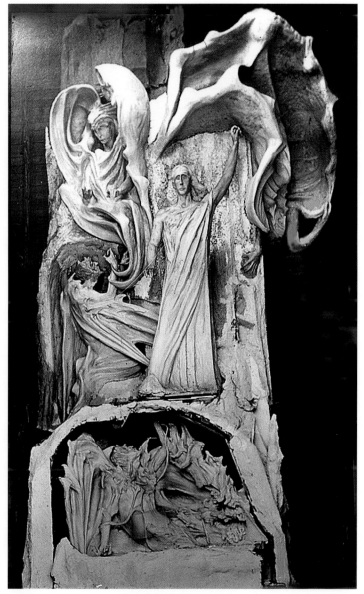

The optical effect of the predominance given by the Falling Lucifer — without the 'rock being'. The large plasticine model, November 1916

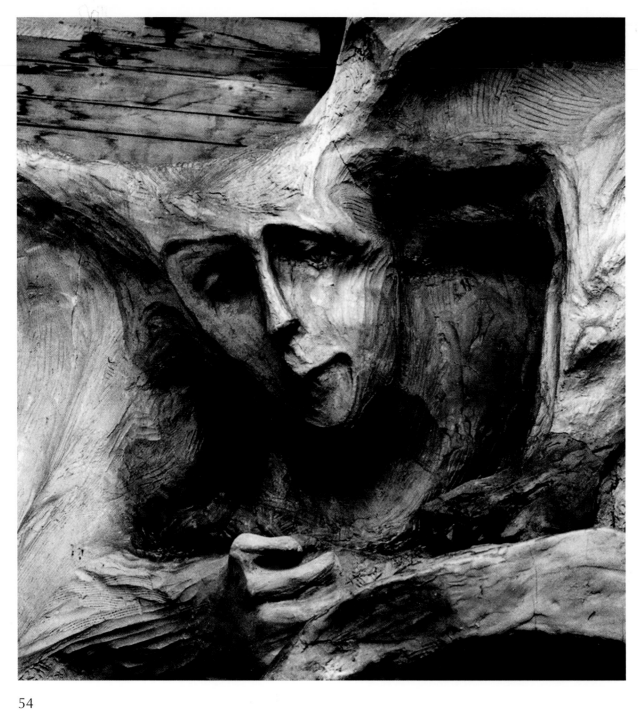

The 'rock being'

rocks is there for good reason. Human beings will not really and truly raise themselves to the spiritual level until they mean to approach it, not by embracing it with egoistic sentimentality, but are able to give themselves to it with a purity of soul that can never be lacking in humour.'

So the 'humourful' rock being who, as an elemental being, has a lively interest in the coming together, in the balancing of all the spiritual forces in human beings as represented in the 'Group', looks down at all that is happening below, embracing the scene with his wings as though growing towards it from another world outside all these happenings.

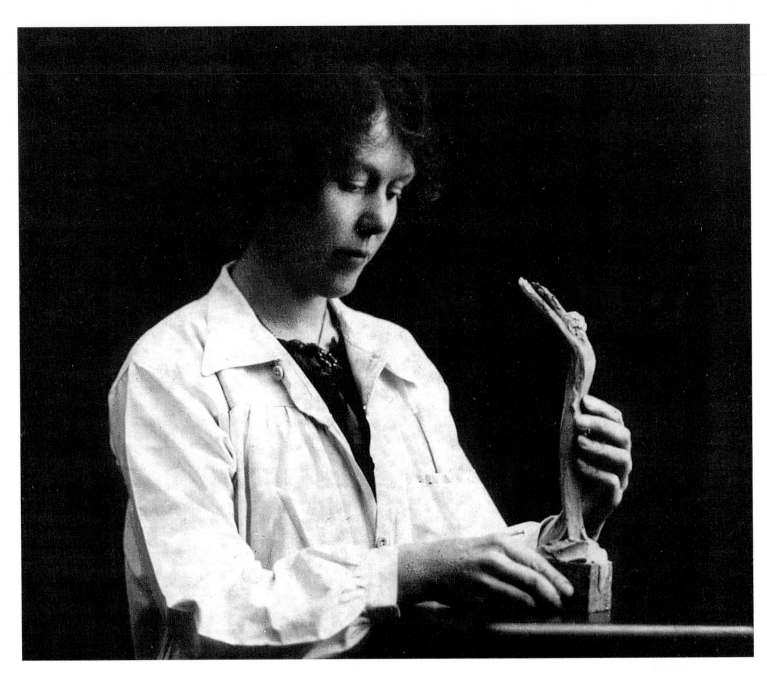

A much later photo of Edith Maryon modelling a eurythmy figure, 1919

Development of the 'Group'

The Work on the Models

John Wilkes

When Edith Maryon arrived in Dornach at the end of January 1914 she immediately became active in Rudolf Steiner's small studio on the eastern side of the extensive joinery workshops in which units for the First Goetheanum building were being prepared.

Initially she helped with architectural models and soon became involved with carving in the building. During that autumn, presumably as the result of conversations they had, she began with the first compositional wax and plasticine model for the wooden 'Group'.

Rudolf Steiner allowed her creative freedom with this first step and indeed it seems he depended upon this initiative in order to be able to proceed with his own contributions. He developed the next model and together with this a colour sketch for the same motif which was to appear immediately above the carving in the small dome of the Goetheanum.

This second model introduced three fundamental changes to the composition. The central freestanding figure took on a stronger vertical gesture. The falling figure of Lucifer on the right was being rotated with the tendency to fall dramatically backwards. Ahriman below entered more deeply into the cave.

Understandably there followed in relatively quick succession from Edith Maryon an enlargement to 1 metre in height, then much larger in volume also, to 2 metres — both with three figures.

In a fifth model Rudolf Steiner now introduced on the left-hand side once more the two adversaries, Lucifer and Ahriman, but in a different relationship to each other. A fully developed small sixth model followed, which brought the composition close to a final stage.

On the basis of this detailed study Edith Maryon could continue her completion of the 2 metre high model. This was then used as the basis for the 9.5 metre high plasticine and plaster model on which Rudolf Steiner himself could eventually convey his more detailed intentions. This process was necessary as a basis for the construction of the laminated wooden blocks, and for the actual carving preparation by a number of helpers.

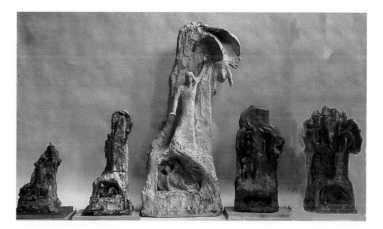

Five of the seven models, exhibited for the first time together after decades, 1965

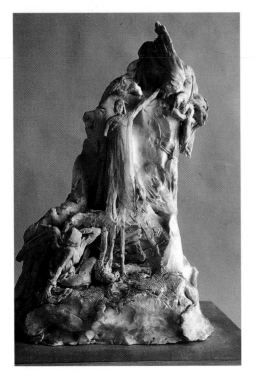

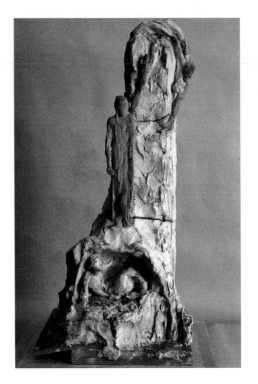

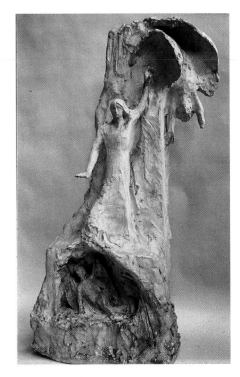

Fig. 1 *Fig. 2* *Fig. 3*

Fig. 1: The first model from Edith Maryon, 36 cm, autumn 1914 (a metamorphosis of the main motif of the building conception expressed sculpturally for the first time)

Fig. 2: Rudolf Steiner's first model, 42 cm. There appear here three further aspects: a strong vertical tendency in the central figure; a rotation in the falling figure, which leads to a dramatic backward plunge of Lucifer; below Ahriman becomes imprisoned in a clearly defined cave in which he chains himself 'in the gold veins of the earth', as Rudolf Steiner says, the densest of substances and materialization of the sun forces.

Fig. 3: It is easy to understand that after the creation of this model by Rudolf Steiner, Edith Maryon would assume that it represents the main themes of the composition. Thus in his absence she continues work on a 1 metre followed by a 2 metre model, both with three figures.

58

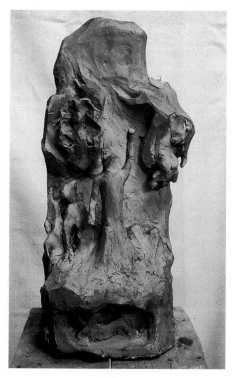

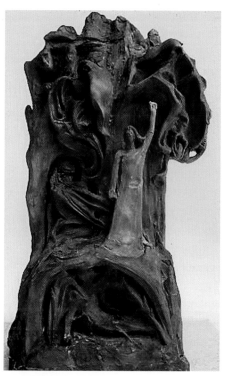

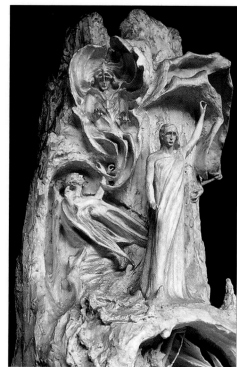

Fig. 4 *Fig. 5* *Fig. 6*

Fig. 4: Here Rudolf Steiner surprisingly brings in new compositional elements, which emanate totally out of movement rather than from observation of nature. He is thus working in a completely modern way, early in the twentieth century, namely bringing spiritual realities to expression through form alone. We have now the two forces expressing their uncompromising wish to dominate in contrast to the initial indication of self-humiliation. Rudolf Steiner comments that artistically it is always important to have at least two facets of a relationship expressed.

Fig. 5: The fifth of the smaller models, 48 cm, July 1915, is produced by Rudolf Steiner in collaboration with Edith Maryon. This appears to have been completed in such detail that it could be a travelling model for the purpose of generating funds during lecture tours. Late in 1916 it was used as a basis for the first sketch of the rock being or World Humour at the top left, to bring the composition into balance.

Fig. 6: Started in sequence as the fourth model, see page 41, this model now becomes the sixth 2-metre high model used for the final enlargement to 9.5 metres. Edith Maryon can bring it up to date with additions made in the meantime within the two previous small models. (Thus the earlier models 5 and 6 are now adjusted to 4 and 5, the 2 metre model now as 6.)

59

Fig. 7: The seventh, full-size model; temporarily freed from scaffolding, a photo taken in November 1916 reveals the first major stage of Edith Maryon's enormous achievement. For the first time it is possible to have an overall uninterrupted view, which makes clear the need to adjust the balance of the composition. This adjustment allows Rudolf Steiner the welcome addition of an elemental rock being or so-called World Humour.

Fig. 8: By comparing the models photographically it becomes clear how the proportions have changed. On the left is the 2 metre model begun in May 1915; on the right is the stage reached with the 9.5 metre model by November 1916. Rudolf Steiner comments that the working of karma has led to the inclusion of this important aspect of humour, which is an antidote for the overwhelming significance of the struggle for harmony. It is indeed so that such beings look with intense interest upon the developments and outcome between human beings and these opposing forces of Lucifer and Ahriman, because their future depends on the results.

Until now we have observed that in every model by Edith Maryon the left hand of the central figure indicates a gesture of aversion towards Lucifer. From models 1 and 3 it reappears in 6 and even 7.

For Rudolf Steiner it was of the greatest importance in his statements that there would be absolutely no element of aggression expressed towards Lucifer.

The gestures of both arms together express an inner state of consciousness, which intends to establish a state of harmony and balance between contrasting forces through the power of love. It is with this intent that Rudolf Steiner finally creates the wooden carving (p. 34).

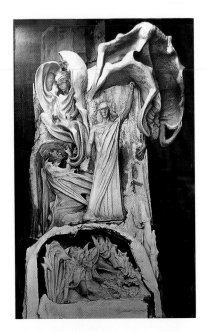

Fig. 7

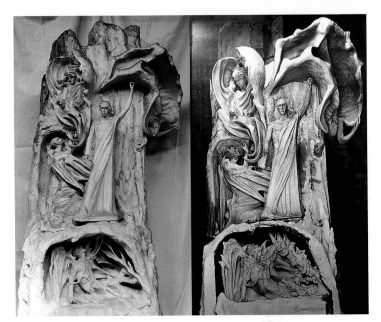

Fig. 8

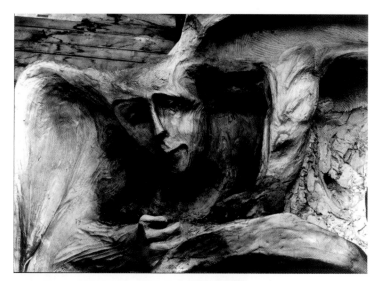

World Humour (or the 'rock being')

Fig. 9: As an example of the stages of development to full size, we take three pictures of the Rising Lucifer. Left the initial preparation by Edith Maryon, centre Rudolf Steiner's amendments and right the unfinished state of the carving prepared by assistants ready for him to complete.

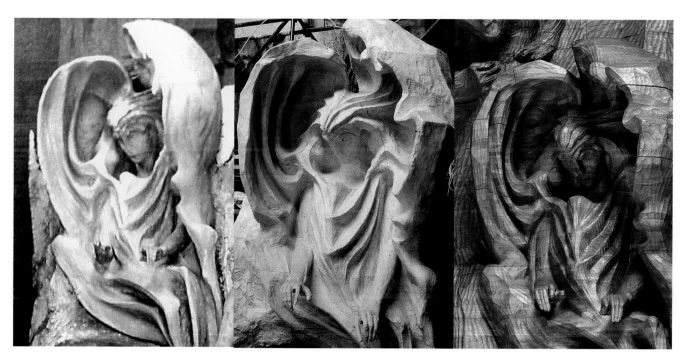

Fig. 9

Fig. 10: Lucifer possesses no head as such ('by Lucifer the head must disappear' said Rudolf Steiner). Lucifer consists more of a metamorphosis of ear and heart organs. He listens only to himself as the total egoist. Rudolf Steiner commented that the sculptural expression of such a being had to be 'humanized' as the observer would be completely overwhelmed by a more realistic or accurate representation.

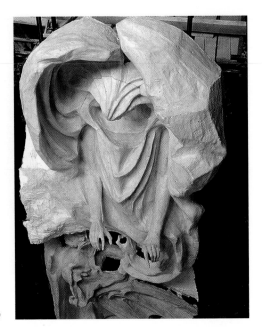

Fig. 10

Fig.11: Ahriman also attempts to appear in human form but can only manifest in a hideously sclerotic way. Similarly he attempts to express the gesture of the central figure. The right arm is stretched downwards not as support but in great tension and spasticity as expressed in the extraordinary hand gesture (see Fig. 15). The left arm is raised in an upward gesture almost beseechingly in response to the caring right arm gesture of the central figure.

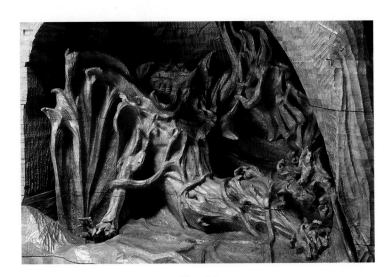

Fig. 11

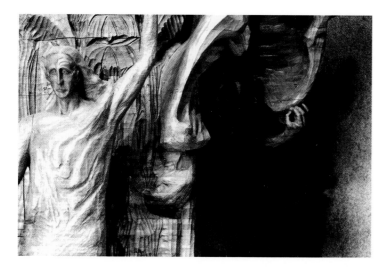

Fig. 12

Fig. 12: Also by the Falling Lucifer the gesture tends to that of the central figure, but not in the way it appears there and cannot create any impression of harmony. The Fall does, however, imply for Lucifer an approach to the human condition. The right arm and hand do indicate human anatomical characteristics. The left hand grasps the rock. In contrast, the Rising Lucifer strives to escape the physical world, which he has indeed never made contact with.

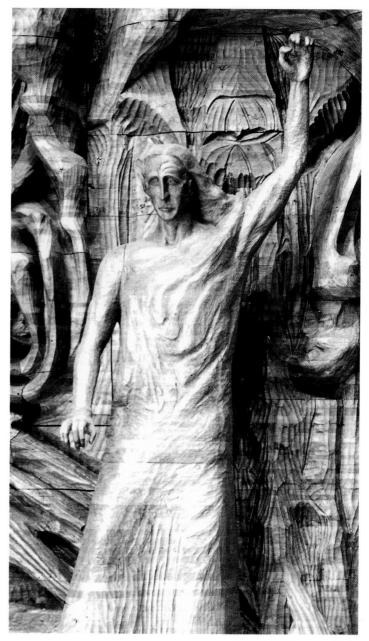

Gesture of the Representative of Humanity, for Rudolf Steiner the figure of Christ

A comparison of the right hands of all three figures. Each figure shows fingers in a threefold relationship but in different combinations.

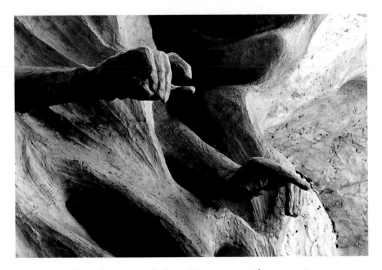

Fig. 14: The hands of the Rising Lucifer are in contrast demonstrating an egoistic gesture and with an upward sucking tendency attempting also to draw Ahriman upwards. Both of their arm gestures remain clamped in a middle region.

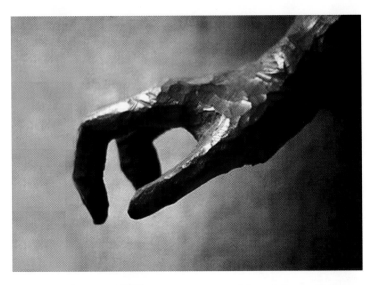

Fig. 13: The central figure appears with a harmonious, as though rising and falling, rhythmically freeing gesture of the right hand.

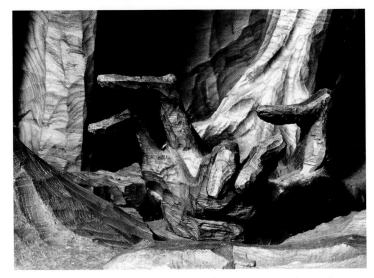

Fig. 15: With the lower Ahriman figure we see the right arm stretched downwards but excruciatingly cramped and spastically withdrawn. (See also Fig. 11.)

In every representation of Ahriman by Rudolf Steiner the head is metamorphosed.

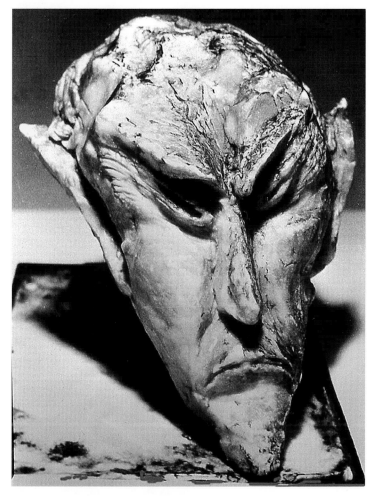

Fig. 16: The original model of Ahriman's head on which all others are based, created in April 1915. Photo from 1965 after its restoration.

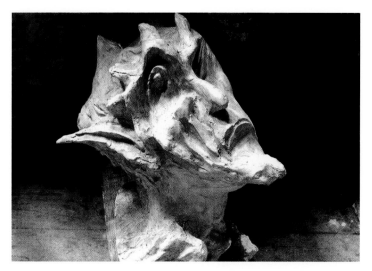

Fig. 17: Plaster detail of the upper Ahriman from the full-size model, end of 1916. Prepared by Edith Maryon from the original (Fig. 16) but transformed by Steiner on the accessible front side.

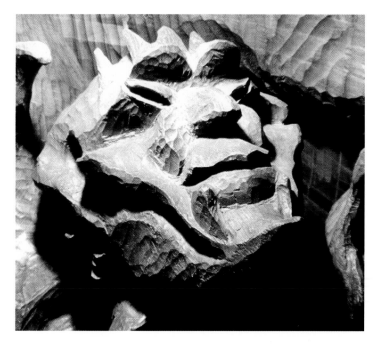

Fig. 18: Lower Ahriman head in wood from Steiner. Probably autumn 1917.

In all details of the whole design the principal of rhythm and metamorphosis was used. Nothing was taken from a physical observation of nature.

Neither anatomical details nor clothing are key factors, but forms which attempt to represent inner realities. Rudolf Steiner and Edith Maryon were confronted by the profound artistic task of representing spiritual realities in the forms of the physical world. This was also particularly relevant to the being representing World Humour.

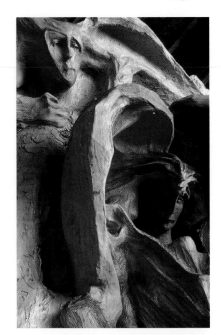

Fig. 19: Due to the already mentioned imbalance in the composition, it was necessary to bring more weight to the upper left-hand corner. Rudolf Steiner did not however want simply to add more mass to the 'rock' formation. Instead he represented a being which belongs to the rock. In this position it was necessary to give it an asymmetrical form, but at the same time Rudolf Steiner saw this as a risk because in the prevailing artistic climate it was something quite new.

Fig. 19

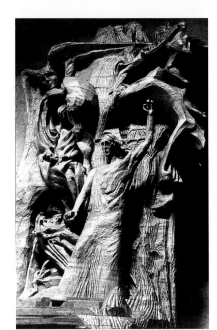

Fig. 20: The human form becomes possible through 'the welding together of the ahrimanic and luciferic tendencies'.
The arm gestures upwards and downwards indicate sculpturally an inner state of consciousness, holding a balance between opposing forces.

Fig. 20

66

Under normal circumstances and for smaller-scale undertakings a sculptor would not wish to create a preparatory full-scale model for a carving. However, due to the complexity and the need for Rudolf Steiner to collaborate with Edith Maryon it was important to sort out the composition together. Also, due to the enormous scale of this work, it was necessary to indicate dimensions and details not only in order to laminate the blocks of wood but to give his helpers more information that was to enable them to prepare the carving. They were to leave adequate material for Rudolf Steiner to complete the work after its mounting within the Goetheanum building. He wished to complete it as a total work of art; architectural, with murals, coloured windows and sculpture.

By 1921 the carving had reached the stage at which we see it today apart from a few details. It was not taken any further; Rudolf Steiner was not yet ready to have it trans-ferred to the Goetheanum and he also wanted Edith Maryon to concentrate on the development and execution of the all important eurythmy figures.

It is indeed the situation that within the carving only the lower Ahriman figure can be considered complete. Rudolf Steiner continued carving on the central figure whenever he had time, for instance before giving a lecture, but it remained unfinished.

Everything else also remained unfinished ready for completion later. There had been a number of artists involved in carving under the direction of Edith Maryon with directions to leave some material for the final cut. This would never have happened due to the burning down of the First Goetheanum on New Year's Eve 1922.

The planks on which the central figure stands remained to be carved when the relationship with Ahriman's extre-

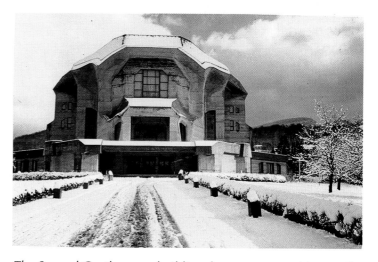

Edith Maryon (upper left) with some helpers. Assya Turgeniev lower left

The Second Goetheanum building demonstrates architecturally, perhaps more dramatically than the First Goetheanum, the same motif as the sculpture: convex angular forms below emphasizing the horizontal, verticality streaming upwards, culminating with concave forms above which help to mould a domelike roof

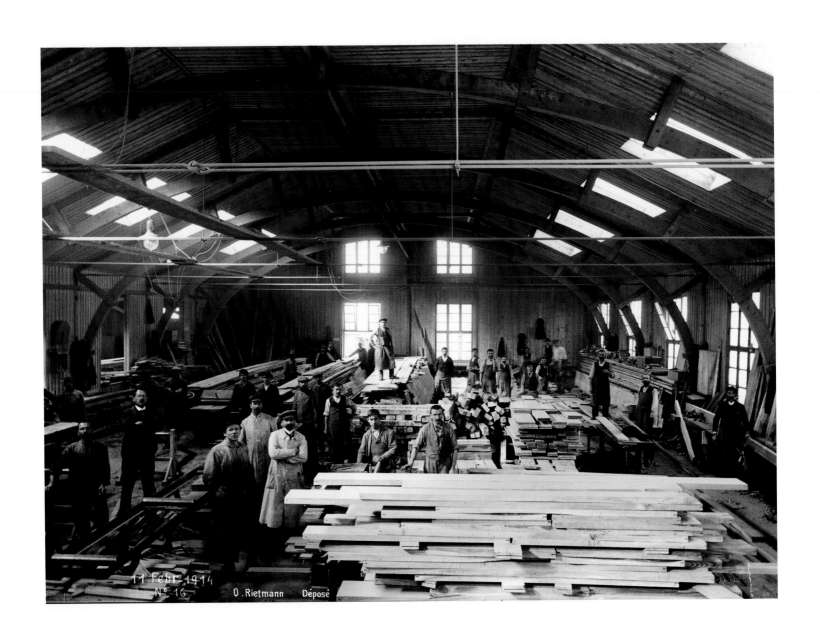

Joinery workshop in February 1914, looking west

Photo by Edith Maryon of co-workers in front of the 13 m 'Hochatelier', which housed the 9.5 metre high model, early 1918. Left, a ramp on which to move the wooden blocks

mities could be properly determined. Indications can be seen in the full-size preparatory model.

It is most fortunate that the carving was taken as far as it is, thus enabling it to be exhibited. Normally the artist would have been left with a blocked out condition, leaving him with more adequate material for completion.

The full-size model was to be completely dismantled according to Rudolf Steiner's instructions; the lower Ahriman and the central figure were the first to go, as they were no longer needed. The workmen were about to continue but Rudolf Steiner lay ill next door and due to his untimely death they were sent away. This means for us that only the figures that remain incomplete in the carving survive in model form and are of great importance as they indicate his intentions with full clarity, although he would not have copied them in wood.

As we are left with an incomplete work of art we have the task to study all remaining aspects, as this will give us the best picture of Rudolf Steiner's intentions.

Neither Rudolf Steiner nor Edith Maryon were able to see the whole carving built up as a total unit. Only in 1928 was this possible when it was moved to the Second Goetheanum building in a specially designed space in the south wing. This was his clearly expressed wish as it was not to be placed on the technical stage in between all the modern machinery.

The original intention for the First Goetheanum was that the sculpture would be placed in the axis of the building at the eastern end on the architectural stage thus surrounded by a carved environment, which mirrored for serious, prepared participants the very special inner condition of an initiation experience. This was intended as an enlightenment in three stages — moving with an awake consciousness through the large hall, the stage and finally to the Representative of Humanity maintaining balance between the two Adversaries.

Finally we can recall the intentions of the First Goetheanum building as an initiating experience with the intention of bringing about an understanding of the human task of establishing harmony among the peoples of the world. This in its purity was no longer possible, which implies that we have still to wait until some future time. It

was to be a fascinating metamorphic essay of the arts in which *the Motif* was to be expressed in all art forms side by side: the building with its two domes, the sculpture as a humanized expression of the battle between opposites and above as colour mural in the dome with its suggestion of the resurrection and redemption of Lucifer, the 'Light Being', now able to transform his gesture towards that of the Representative of Mankind; also the engraved glass windows, the spoken word, the art of movement, drama, music — altogether creating the total art form.

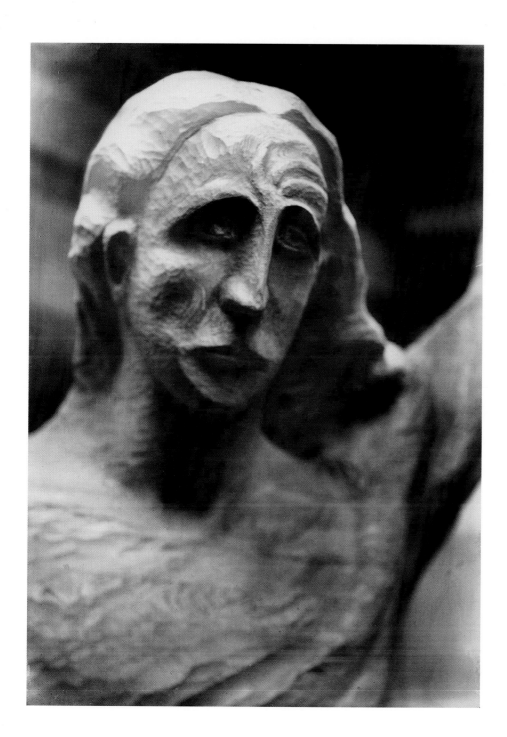

Edith Maryon — 1912

Rudolf Steiner — 1915

The Significance of the Collaborative Work of Rudolf Steiner and Edith Maryon in their Respective Biographies

Judith von Halle

The entire qualifying impulse inspiring the cooperative work of Rudolf Steiner and Edith Maryon is the central all-embracing esoteric force that was the engendering spark of both Edith Maryon's spiritual connection with Rudolf Steiner and of the artistic work they did together: the Christ Mystery.

Since her young days, which she spent in London, Edith Maryon had felt drawn to the question of a real understanding of the Christ Being, and was finally prompted to join a Rosicrucian style order.[7] She studied sculpture at the Royal College of Art and repeatedly exhibited her models at the Royal Academy. Many of these works that arose before she met anthroposophy show a great deal of her inner leaning towards the subject of Christianity. Besides a model of Michael, the relief 'The Seeker of Divine Wisdom' and 'The Cross of Golgotha' deserve special mention. These works are particularly precious in view of the later transformation that took place in Edith Maryon's artistic work

A roughly 1.3 m high painted plaster cast of Edith Maryon's 'The Cross of Golgotha'

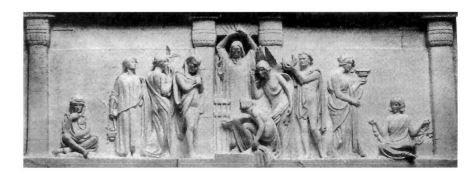

Edith Maryon's relief 'The Seeker of Divine Wisdom'

73

after she met Rudolf Steiner. There was hardly any other artist coming to work in Dornach before her capable in the way Edith Maryon was of sacrificing — that is, largely giving up her own deeply rooted style, born out of the aesthetics of Greece, in favour of a new Mystery art.

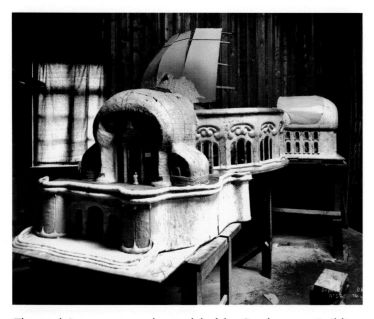

The work in progress on the model of the Goetheanum Building, summer, 1914

Yet it was just this fateful rootedness of her individuality within the fourth post-Atlantean 'Graeco-Latin' cultural epoch that became of decisive importance for Rudolf Steiner in the success of the wooden model in Dornach.

The year 1912, in which Rudolf Steiner gave his lecture in Cologne on the future artistic presentation of the Christ Being (see Chapter 2, p. 48), was the same year in which he and Edith Maryon met personally for the first time. For Edith Maryon this meeting was life determining. She made a quick entry into the Esoteric School, and within a few months she decided to leave behind her altogether the life she had led up until then in London and to throw herself — virtually penniless — into the risky business of a move to Munich. Once she was there, in the care of Sophie Stinde, a loyal colleague of Rudolf Steiner's, she learnt very quickly sufficient German so that she could soon take a full part in Rudolf Steiner's lectures. In the Mystery Dramas she joined the chorus of the sylphs, which enabled her early on to acquire an esoteric approach to the plays, and led later on to the production of several reliefs of motifs in the dramas. In the same year, in the autumn of 1913, she moved to Berlin, to Motzstrasse, and had an apartment there directly under Rudolf Steiner's. At the end of January 1914 she finally moved to Dornach, working to begin with on the models for the Goetheanum building that was being built, as well as to taking on the management of a group of people carving the architraves for the big hall.

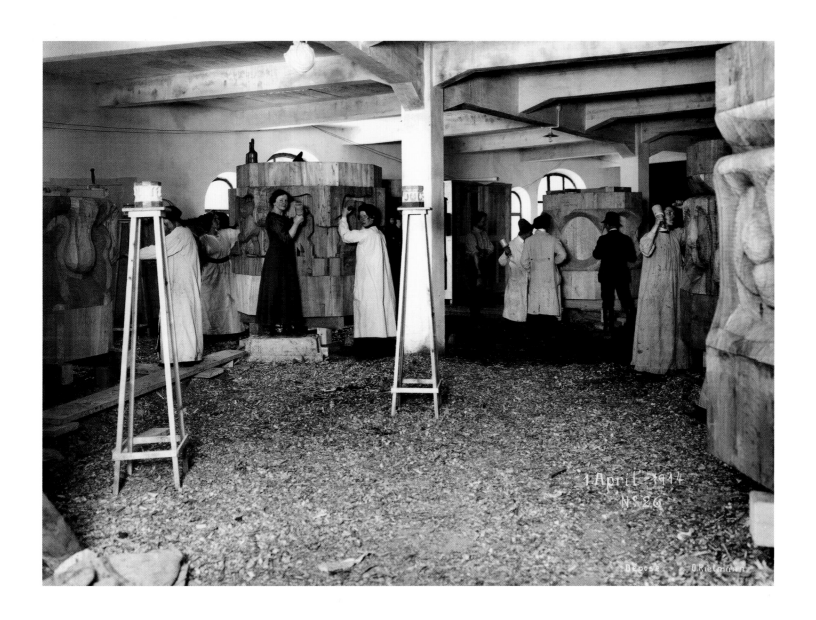

1 April 1914
No 26

Déposé O. Rietmann

75

Very soon an extremely fruitful work began between Rudolf Steiner and Edith Maryon, concentrating on a sculptural presentation of the Christ based on knowledge gained through spiritual science. To grasp the Christian Mystery as a total living process through the workings of various spiritual powers was the task that was to lead to a tangible physical presentation, as a path of knowledge for the esoteric student. Thus very soon the first of a number of development models appeared. From now on Edith Maryon devoted herself almost exclusively to this process with endless devotion, humility and loyalty.

In the early weeks of the year 1915 Rudolf Steiner had a simple studio erected for this joint work next door to the joinery workshops (known as the Schreinerei). It was the studio, which was later called Rudolf Steiner's studio, in which during 1924 and 1925 Rudolf Steiner spent the last months of his life, at the feet of the unfinished Christ figure — spiritually creative until the end.

An aerial photograph from the year 1921
1. The First Goetheanum (1913–22)
2. The high ceilinged studio built in 1916
3. Rudolf Steiner's studio, built in 1915
4. School for further education, later demolished
5. Edith Maryon's apartment on the first floor of the lower 'Eurythmy House' with a view of the Goetheanum
6. House Duldeck
7. House Brotbeck, nowadays the Rudolf Steiner Halde
8. Glass House, where the coloured windows were engraved
9. Heating House

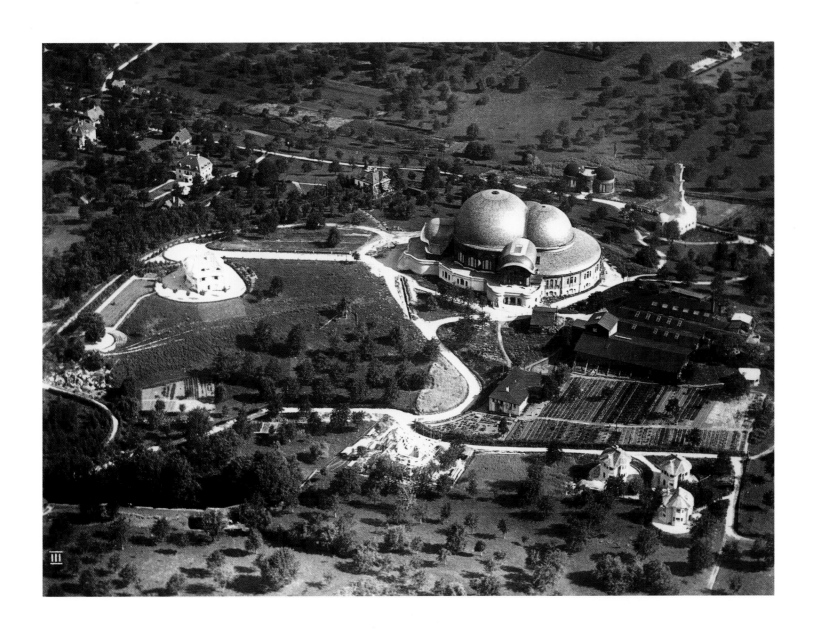

Just how significant the work on the 'Group' was emerges from the special foundation stone laying for the studio, which was attended solely by Rudolf Steiner and Edith Maryon. After the words of the Christ 'When two or three are gathered together in my name, there am I also' then, according to Rudolf Steiner, at that spot of the Foundation Stone a totally new piece of earth was created, in that a fragment of the etheric geography which through her birth had become connected with the individuality of the English woman, and then brought a long way to Dornach, became joined with that of an Austrian, accompanied by the will impulses to undertake a communal task entirely devoted to the Christ — to make way for something to arise on this patch of earth dedicated solely to the Christ Impulse. In this way there was created at this spot an etheric-geographical focal point that arose solely out of the Christian Impulse of two people working together. To mark this communal work there are the signatures of Rudolf Steiner and Edith Maryon on the 2-metre high model they undertook to build above the Foundation Stone. Therefore it is not surprising that Rudolf Steiner decided to carve the wooden model of the Representative of Humanity on that particular spot, and also to pass across to the spiritual world from the bed that stood just at that place.

In the winter of 1916 there occurred the fateful situation of Rudolf Steiner almost falling from the scaffolding in the high ceilinged studio built the previous year next door to Rudolf Steiner's studio. This was where the 9.5 metre high plasticine model was made (this presented detailed dimensions necessary for the making of the wooden model). With immediate presence of mind Edith Maryon caught hold of her teacher as he fell, saving him from serious injury, if not actual death. Not until he was giving the memorial address on the occasion of Edith Maryon's death did Rudolf Steiner speak of the event, which had

1. Edith Maryon's high ceilinged studio
2. 9.5 metre plasticine model
3. Surrounding gallery and the scaffolding in front of the 'Group'
4. Rudolf Steiner's studio in which the 2 metre model arose and was also carved later on
5. Ramp for rolling the wooden blocks up
6. The place where the lower Ahriman figure was kept for many years when being made in wood
7. The place where the Representative of Humanity stood for many years while in the process of being made
8. 2 metre model
9. Entrance to the Schreinerei complex

been strictly kept secret up until then — a happening that created a profound karmic connection between two individualities. Rudolf Steiner described it as a 'clear karmic symptom', and at the memorial service on 6 May 1924 he said the following words:

'This conviction [of really genuine human cooperation] was in the highest degree part of the whole nature of Edith Maryon's calm presence. The fact, of course, that various things came into consideration in working with me can surely be mentioned now to a wider circle on today's occasion, when we are having to bid farewell to the earthly remains of Edith Maryon, and in the future shall be seeing her moving into light-filled eternity as her soul works further in its upward striving. It was fairly near the start of our sculptural activities at the Goetheanum in Dornach when I had to work in the outer studio, that is in the large front studio, up on the scaffolding next to the figure of Christ in our model. That was the moment when, because of a gap in the scaffolding, I ran the risk of falling off, and I would definitely have fallen with my whole body onto a post with a sharp point if Edith Maryon had not caught hold of me. So it has to be said, my dear community of mourners, that the Anthroposophical Society in a certain way, if it believes that my activity has since then been of value to them, owe their gratitude to this deed of rescue. Very little has been said about this, because it was not in Edith Maryon's nature to say much about what she did, particularly what she did for other people.'

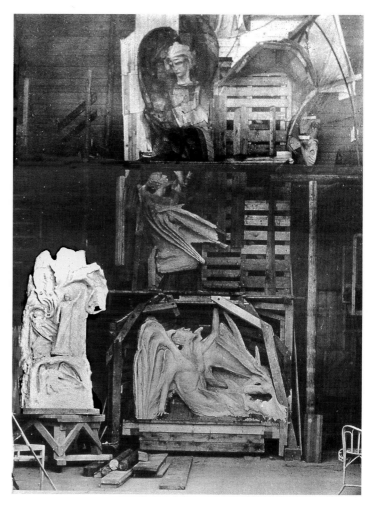

An early stage of the large model in the high ceilinged studio, during 1916. On the left the 2-metre tall model they worked from

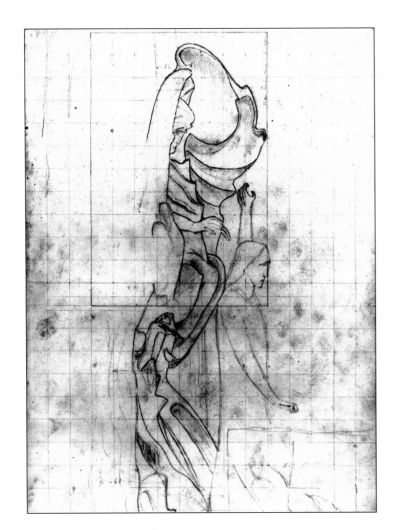
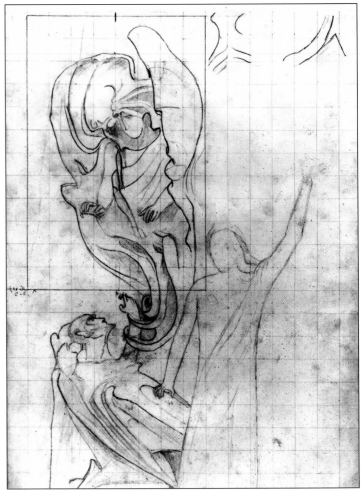

Structural drawings by Edith Maryon for the 1:1 plasticine model

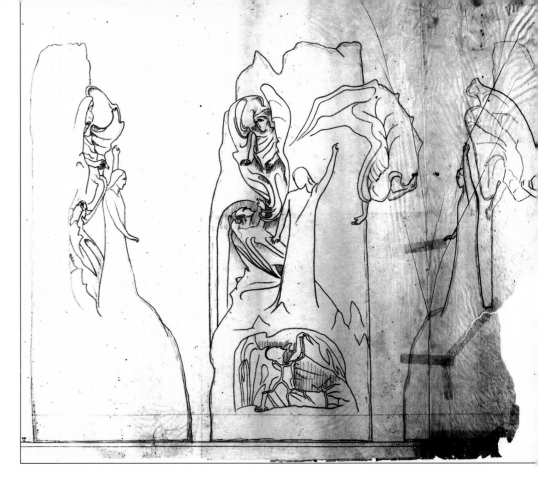

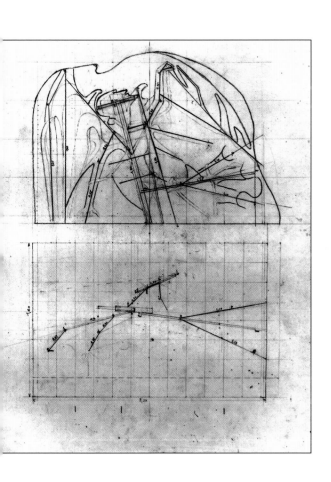

Part of what Edith Maryon brought to her work in a human way — and which was not spoken about — was the consequence of her karmic biography with regard to the already mentioned fourth cultural epoch, especially with regard to the Mystery of Golgotha which occurred in that period. It was of decisive significance for the creation of the 'Group' that two people with different but complementary karmic biographies experienced the Mystery of Golgotha and almost 2000 years later took hold of the kernel of the Mystery on a soul/spiritual level and together transformed it into art. Rudolf Steiner, who, from the spiritual plane, had accompanied the event of the Christian Mystery, and therefore had had a broad spiritual view of it, joined his spiritual research to the technical abilities of an individual who had been incarnate during the Mystery of Golgotha, and was therefore in a position, physically, to transfer to the 'Group' with her own hands what her soul had received at that time, when she saw the Redeemer with her own eyes.

It was primarily this that made Edith Maryon, alongside Marie Steiner and Ita Wegman, one of the closest colleagues and pupils of Rudolf Steiner.

Let us also clarify for ourselves the time dimensions of the period when Rudolf Steiner and Edith Maryon worked together. For years, besides all his other activities (his lectures and journeys, his efforts with regard to the threefold social order, the founding of the Stuttgart Waldorf Steiner School and the clinic, the developing of the art of eurythmy and speech, and many other things) Rudolf Steiner stood, day after day, beside his colleague in the high ceilinged sculpture studio. During this time they not only worked with their hands, but also conversed intensively on every imaginable subject — from art, through politics to things of the deepest spiritual concern. Over and above this his studio had become for Rudolf Steiner a refuge of inner peace in which — well protected from visitors by Edith Maryon — he could both do a lot of esoteric work and also relax. On the barred door they put up a notice saying: 'Please do not disturb, work is in progress!' And so a great many letters from Rudolf Steiner to Edith Maryon, which he wrote to her when he was away on lecture tours, described his wistful longing to be back at work again in the studio as soon as possible: 'When away on other tasks I keep thinking of our sculpture studio. This is inevitable, because it brings strength. I shall be really happy to be back.'[8]

The complete confidence Rudolf Steiner had in the way Edith Maryon put her whole heart into the new Mystery art he was calling into life is evident from the statement of his, passed on by Assya Turgeniev, who worked with Edith Maryon from time to time: 'What she does I have done!' The establishing of this fact actually referred back to the situation that during his absence people did not want to carry out any instructions given by Edith Maryon, which mostly came from him anyway, so by saying this he hoped to avoid, once and for all, any delays due to this, or any corrections that were essential. Nevertheless, as Assya Turgeniev records in her memoirs, there inevitably arose from this the following conclusion: that Rudolf Steiner 'had taken on the full responsibility for everything Edith Maryon did. Prior to this, if Edith Maryon had made a correction that people either did not understand or were not in agreement with, it was still possible to go to Rudolf Steiner and find out what he thought about it. Because of this statement of his, this was no longer possible. From now on, if she made a correction, that was the last word!'[9]

A sphere of trust such as this, coupled with her persistent reserve, aroused considerable envy and resentment, which became even more pronounced as Rudolf Steiner's visits to her sickbed, for over a year, became more frequent, and their joint spiritually creative work grew more intense. Yet

the whole of what they did together served solely to promote the unselfish aims of anthroposophical work.

On the night of New Year's Eve 1922 Edith Maryon saw the destruction of all the perspectives she had been aiming for until then, encapsulated in the erection and completion of the Goetheanum and its heart, the modelled 'Group', when the Goetheanum, which contained the whole of her lovingly dedicated work, became the victim of arson. From one day to the next the centre of her life was taken away. She had to see her teacher suffer an inner collapse, which he described by saying that his limbs were now moved solely by his higher will; that his higher being had, since the fire, separated from his physical body. The prospect of the Mystery temple, which had stood on the hill almost completed, was beyond restoration, as Rudolf Steiner remarked, and the sudden emptiness in which her continuously active hands now reached out gave Edith Maryon an incurable form of tuberculosis of the lungs, to which on 2 May 1924 she succumbed.

In the weeks running up to the re-founding of the Anthroposophical Society, during the Christmas Conference of 1923 Rudolf Steiner had appointed Edith Maryon to be a member of the executive Council — an office which, on grounds of health, she had to refuse, and which was taken on by the astronomer Elisabeth Vreede whom she recommended. Edith Maryon did, however, consent to take over the leadership of the Section for the Fine Arts.

The months spent on her sickbed, bad as they were, allowed for a tremendous amount of fruitful, creative work to be done between Rudolf Steiner and Edith Maryon of which, in view of the fact that almost all the records of it have disappeared, the extent and the significance can hardly be documented for preserving in the archives, which is why, afterwards, we are having to turn to the spiritual chronicle to enable us to supplement the remaining notes. Rudolf Steiner made a reference to this work they did together within the circle of the First Class of the School of Spiritual Science on the day of Edith Maryon's death: '...for she was first and foremost among those who have devoted themselves with heartfelt earnestness and true devotion to what this First Class has given them... Therefore to her the esoteric sphere was of the utmost importance, and she lived within it with the greatest intensity during the years she was among us on the physical plane...'

In the last salute with which he ended his address at Edith Maryon's cremation, Rudolf Steiner indicated the connection between the two of them, which had distinguished the whole of their joint artistic achievements.[10]

The smoking ruins of the Goetheanum, January 1923. The high ceilinged studio on the left

View of the ruins of the former hall containing the stage

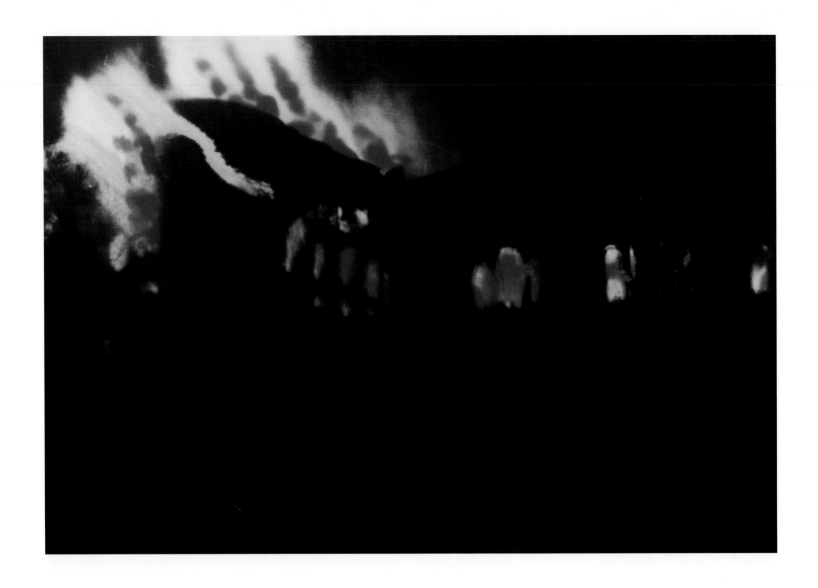

An image of the burning Goetheanum, said to be a photograph

An Insight into the Essence and the Significance of the 'Group' for the Present and Future

Judith von Halle

If we want to make a true statement regarding the significance of the 'Group' for the present and future we shall have to begin by developing a feeling for that particular setting in which it was first envisaged, which means looking back into the past. This setting was an entire work of art in itself, the First Goetheanum, in which this whole sculpturally modelled 'Group' was to be its crowning glory.

The significance of this work of art is not merely exoteric, that is to say, of a material or aesthetic nature, but primarily esoteric. The completing of the work on the 'Group' was intended to happen within the Goetheanum building, because the connection with the spiritual beings, in particular with the living etheric Christ Being in the model, had to take place within the Mystery temple of the Goetheanum building itself. However, Rudolf Steiner had had a premonition of the destruction of this unique building as early as the night of his first visit to Dornach, when he was staying in House Grossheintz (the family who had put the plot of land on the Dornach hill at his disposal). But as it is forbidden for an initiate of a 'white lodge' to intervene as it were in a human destiny, therefore also his own, work was begun on the building without consideration of the approaching danger. Rudolf Steiner spoke only to a few individual members about the circumstances that threatened. In the years 1921 and 1922 the situation with regard to the drawing up of the opposing forces seemed to be becoming so critical that in response to requests or enquiries from members and visitors as to whether the 'Group' could be brought across from the studios to the Goetheanum buildings Rudolf Steiner and Edith Maryon always gave the same answer: 'The Group will not be carried across. There is time enough.'

So the 'Group', as the scene of action where living spiritual beings were at work, was entirely bound up with the construction and esoteric content of the First Goetheanum. The twelve thrones, or rather the proportion of these thrones installed at the base of the pillars in the smaller of the two halls, refer to the planned presence of these spiritual beings within the building, for their proportions are 'angelic' and not human. (See illustration on p. 28.)

We can assume that the actual Being of this work of art would only have been able to begin to 'speak to us' when in harmony with the finished building; that the completion of the twelve pillars of the smaller hall would only have been arrived at by the presence of the 'Thirteenth', the 'Representative of Humanity', which would at the same time have brought the actual force of the 'I' into the soul members being given form in the inner space, and being given a 'body' in the outer architecture.

In view of this we can imagine how important it was that the 'Group' was placed, in a literal sense, in the right setting — that this was in fact of the utmost significance for the actual active effect of the essence of the 'Group'.

On 26 December 1922 Rudolf Steiner handed his pupil

Edith Maryon a mantric verse. In contrast to the verse he had given the day before to Marie Steiner ('The stars once spoke to human beings...'), this one for Edith Maryon did not at all seem to have a Christmas character. One can only be surprised at its mood and content if one does not bear the actual situation in mind. This verse shall be quoted here because it is a touching testimony to the sensitive preparation Rudolf Steiner was making in giving it to his pupil Edith Maryon who was, of all his Dornach pupils, most closely associated with the Goetheanum building and its Mystery secrets.

This verse was meant on the one hand to protect Edith Maryon from receiving too great a shock at the sight of the burning Goetheanum Building. It is being quoted here primarily because — five days before the fire — it points in a unique way to the future, to the time after the loss of the building, especially to what would be left of the material labour, all of which would be scattered in sparks and atoms:

When human beings discovered the way the world
dispersed endlessly in atoms
they accepted an understanding of the death of nature;

They should now strive to find in spirit what will
 overcome
the dead remains, and they will direct their
understanding
to world becoming.

Edith Maryon experienced, as it were, during the night of the fire, a second Golgotha. But she now had to find what overcomes the dead remains, and she had to be strong enough also to be able to take part in a second 'resurrection'. She had to seek the Goetheanum building in the spiritual realm, seek for the spiritual meaning of it. Therefore Rudolf Steiner showed her, by giving her this verse,

that in the artistic realm one should not cling to the material aspect. Executing the work of art in material form was certainly of utmost importance, and had to be done. If, however, human beings enter with the right attitude into their work they will be creating imperishable work at the level of angels, creating in the way angels think. The work will then have eternal existence, and the material image of the actual work of art is free to fall away from the lasting spiritual work of art, as ashes dispersing in atoms.

After the burning down of the First Goetheanum the 'Group' could no longer carry out its actual intended task. This must be thoroughly understood; and this fact also explains the final words of Rudolf Steiner, which sounded like the concluding statement regarding the destiny of the 'Group', and which was included in a lecture he gave three months after the fire; they also make clear, most movingly, the spiritual value of the Group: 'This 9.5-m high "Group" modelled in wood, in which the Representative of Humanity is portrayed as Christ in the struggle against the temptations of Ahriman and Lucifer, was intended to serve as a gathering together of everything that lived in form and that could ever be spoken or artistically portrayed in the Goetheanum.'[11]

This particular mantric verse showed Edith Maryon, however, a new direction for the 'Group'. Rudolf Steiner had made the remark to her in this respect, after the fire: 'They have not been able to take the essence of it away from us.'

So now, and in the future, we shall indeed be able to see in the 'Group' the essential Being of it, which can be found in the spiritual realms. The Anthroposophical Society experienced this 'resurrection', this rising up of the phoenix from the ashes, in the Christmas Conference that followed in the coming year, in which Rudolf Steiner gave the so-called spiritual foundation stone to the members in the form

of a mantric verse — the foundation stone of a spiritual building that could never be destroyed by exterior forces.

Edith Maryon could still experience this spiritual resurrection on the physical plane. On the day of her death Rudolf Steiner set up for the members that spiritual building, which stood on the spiritual foundation of the Christmas Conference, with a mantram of the First Class of the School of Spiritual Science. This was to serve as a supersensible signpost for Edith Maryon's last passage to that Grail Castle, for the coming into being of which she had devoted her life, and which she had once upon a time hoped to enter in the sense world; yet it was at the same time also a supersensible signpost for all those members following later, whose task it can be from now on, with the help of the impulse of the First Goetheanum building that has passed through the spiritualizing processes of combustion, to link up with the First Goetheanum by means of a metamorphosis on the physical plane which the kind of art — the kind that functions on such a high level — is capable of achieving.

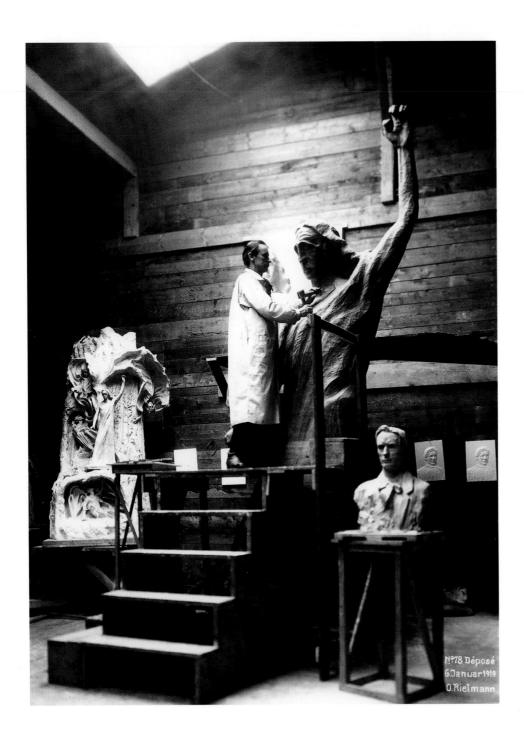

Nº78 Déposé
6.Januar 1919
O.Rietmann

Why 'Wooden Model' and not 'Wooden Sculpture'?

The choice of the phrase 'wooden model' to describe the so-called Dornach 'Group' occasionally leads today to the assumption that it came about in ignorance of the etymological origin and meaning of the concepts 'modelling' and 'sculpture'. In the history of art we distinguish between the technical terms 'sculpture' and 'modelling'. Whilst 'modelling' describes a process of moulding in which material is added on, i.e. plasticine or clay, sculpture is clearly a process in which material is taken away. Work of this kind is usually carried out in wood or stone. So the idea of modelling in wood would be a contradiction in itself.

Yet the title of this book was consciously chosen to be the 'wooden model', for it was Rudolf Steiner himself who used this concept, and very likely even coined it. At the same time we can probably assume that Rudolf Steiner, who laid tremendous value on the precise meaning of words as is particularly evident in his book *The Philosophy of Freedom*, must well have known of the discrepancy between both the concept of the material itself as well as the concept of the method of working with it, which would appear from his coining of a new expression. In fact not least of all Rudolf Steiner had around him some fairly well-known sculptors with both professional and practical experience who would definitely have had knowledge of the accepted classification of the concepts of modelling and sculpture.

We should rather hearken to Rudolf Steiner when he uses a newly coined phrase such as that for the creative achievement of the 'Group'; and we shall very soon find in everything Rudolf Steiner said about it a rich variety of indications as to why the apparently contradictory concept 'wooden model' was used again and again.

Rudolf Steiner's concern, in the sculptural work on the 'Group', was to work in a 'supersensible-naturalistic way',[12] so to say. Something that has never existed before in Christian art was to be brought about. On the other side of the threshold to the sense world, in the purely spiritual realm, the real being of the spiritual entities Lucifer, Ahriman and the Christ were to be observed, and then, in the full nature of their being, be made visible in the sense world by means of an artistic process. It was not to be a symbolic image of these beings, born out of the genuine imaginative powers of the artists. But the spirit beings themselves had to 'sit for their portraits' in order to stamp upon the 'Group' their unvarnished, true being — even, as it were, ensoul it. To achieve this, a huge task — both in the spiritual as well as in the sculptural sense — had to be accomplished. And, taking one step at a time, the artists succeeded in bringing the spiritual beings by way of the material element into the realm of the senses, in their unveiled characteristics, showing qualities that were otherwise hidden behind the veil of the senses, and — in the case of the adversary powers — could rule with impunity. It was becoming possible to make living spiritual beings visible in the realm of the senses through modelling.

Admittedly, in other contexts Rudolf Steiner also spoke of it as a sculpture. It was the Christian motif[13] in particular

that Rudolf Steiner had in mind to carve out of the wood, to release it as it were from being nailed to the wood of the cross at the turning point of time, and to enable it to appear clad in the forces of the Resurrection in which it is manifesting in the era of a return within the etheric realm.[14]

Therefore they distinguished carefully between the concepts. And when the concept 'wooden model' was used, the person who chose it was thinking of the process that in a living way combined spiritual beings being expressed through the art of modelling with the sculptural activity going on in the wood. For spiritual beings actually to take on form by means of art in the realm of the senses they have to enter into the activity of modelling. Through the shaping of the wood spiritual beings began to be moulded into form in the world of matter.

In his lecture of 6 January 1918 Rudolf Steiner connected what is hidden in or behind the sculptural work of the 'Group' with the veiled figure of Isis, though in the form of a Christian myth in which Isis and Osiris are reversed. The 'Group' at one and the same time both hides and uncovers this new Isis myth, and both the meaning of this myth as well as of the 'Group' itself will only be understood when that world behind the veil of the senses appears in its full reality in the consciousness of people today. But at present the 'Group' is right in the middle of the 'Land of Philisterium', the 'Land of Scientific Profundity', which leads to there being few people who recognize the 'Group' for what it is.

In a similar way the new expression 'wooden model' is in a difficult position today; for in our 'Land of Scientific Profundity' in which the Word is no longer assigned the life-giving and spiritually real significance that it still had in the prologue to St John's Gospel, it does not seem to be understandable except as a contradiction in terms. Where the reality of the spiritual world is not considered — is not or will not be acknowledged — words have to serve pure intellectualism; they are robbed of their actual living strength and meaningfulness, and a concept such as the one used here, in disregard of the divine-spiritual origin of the word, tends simply to be laughed at, dismissed as an error or used out of ignorance.

The choice is between a concept belonging to art history — a technical term — and a spiritual-scientific concept to do with the enlivening forces of art. In the case of the expression 'wooden model' this newly created description, which is paradoxical in the purely technical world, serves in the discovery of a spiritual-scientifically correct and living concept and understanding.

About John Wilkes and the work he carried out in Dornach

During the work being carried out for the completion of the western part of the Goetheanum in the 1960s John Wilkes together with Rex Raab and Arne Klingborg developed an initiative to deal with the deteriorating state of Rudolf Steiner's architectural and sculptural legacy. In 1956 on his second visit to Dornach, Wilkes became aware that most of the models were in a rather poor state of repair. He also saw to his surprise that original wax models were being used by students and left unprotected between clay models. It became evident later on that during this same period Edith Maryon's studio was being cleared and, without a thought for their origin, models were thrown out and became a pile of shattered plaster fragments. It seems that Herr Waldemar Kumm was shortly afterwards passing by and it was entirely due to his presence of mind and initiative that these sculptures were rescued. They turned out to be models that Edith Maryon had shown to Rudolf Steiner who had studied them and in some cases made very important additions. These damaged models were passed on to Wilkes some ten years later and were repaired. However, a number of works such as the portrait bust of Rudolf Steiner were wantonly destroyed, as witnessed by Herr Kumm.

For John Wilkes the major task was now to maintain the full-size model in plasticine and plaster prepared by Edith Maryon and worked over by Rudolf Steiner in the so-called Hochatelier. After a thorough restoration, which included assembling like a three-dimensional puzzle all the broken-off pieces gathered from the surrounding area, a complex piece-mould and plaster cast could be completed.

The original plasticine head of the central figure by Rudolf Steiner was obviously also in danger of falling apart and needed urgent and dramatic attention. Especially the back of the head was seriously crumbling away due to excessive temperature fluctuation. It was possible to replace missing parts by making pressings from the original plaster cast used by Rudolf Steiner during his carving activities.

The original small paraffin wax head of Ahriman, due to the excessively hot summer of 1949, had almost become a puddle of wax. Even in its collapsed state it was later also preserved by the foresight of Waldemar Kumm in quite different circumstances. He passed it on to Wilkes who built a special cupboard in which the model could be slowly warmed up under constant supervision over a number of hours, until it became possible to gradually re-establish its original vertical position.

Five of the smaller compositional models, separated at an early date, could now also be reunited after a number of decades. They were restored where necessary, moulded in a new rubber material, which made the process for the first time possible without damage to the originals, and cast in plaster. This action allowed the complete set to be exhibited for the first time.

The main work was completed by the beginning of the 1970s. However, in 1987 Wilkes had to return, having

observed that the Falling Lucifer head was beginning to drop away from its armature due to its own weight and continuing temperature fluctuation. This had to be taken apart and rebuilt to connect more intimately with its wooden core.

Apart from a few minor problems the model has remained stable.

It is only in more recent times that a relatively even temperature has been achieved in the studio due to renovation and insulation. However, an extra cooling system has now been made available for the warmest summers. Unfortunately access to the cold air below the Schreinerei, which Wilkes had experienced in the 1960s by opening up the floor, was cut off during building renovations despite his repeated requests.

Notes

1. See Rudolf Steiner's lecture of 5 December 1920 (not translated) in *Die Brücke zwischen der Weltgeistigkeit und dem Physischen des Menschen* (GA 202), Dornach 1993, p. 72.
2. Rudolf Steiner, *Four Mystery Dramas* (GA 14), 'The Portal of Initiation', Scene 8 (Rudolf Steiner Press, London 1997).
3. Rudolf Steiner, lecture of 13 December 1919, in *Mysteries of Light, of Space, and of the Earth* (Anthroposophic Press, New York 1945).
4. See Rudolf Steiner, *Theosophy* (Rudolf Steiner Press, 2005).
5. See also Rudolf Steiner's lecture of 10 September 1908 in *Egyptian Myths and Mysteries* (Anthroposophic Press, New York 1971).
6. See Rudolf Steiner's lecture of 8 May 1912 (not translated) in *Erfahrung des Übersinnlichen, die drei Wege der Seele zu Christus*, GA 143 (Rudolf Steiner Verlag, Dornach 1994), p. 185.
7. For her biography, see Rex Raab, *Edith Maryon, Bildhauerin und Mitarbeiterin Rudolf Steiners. Eine Biografie mit zahlreichen Abbildungen und Dokumenten* (Verlag am Goetheanum, Dornach 1993).
8. See the letter of Rudolf Steiner to Edith Maryon in Rudolf Steiner/Edith Maryon, *Briefwechsel 1912–1924*, GA 263/1 (Rudolf Steiner Verlag, Dornach 1990), p. 64, Letter no. 65.
9. See Rex Raab, op. cit., p. 204.
10. See the verse for Edith Maryon from Rudolf Steiner's address at her funeral, on page 6 of this book. This version of the verse is taken from Peter Selg's book *Edith Maryon, Rudolf Steiner und die Dornacher Christus-Plastik* (Verlag am Goetheanum, Dornach 2006), page 222f. The mantra was originally published in volume GA 263 (p. 229f.) of Rudolf Steiner's Collected Works, in a different, less personal, version.
11. See Rudolf Steiner, *Was wollte das Goetheanum und was soll die Anthroposophie?* (not translated), GA 84 (Rudolf Steiner Verlag, Dornach 1986), p. 42 f.
12. See Rudolf Steiner's lecture 'The Supersensible Origin of the Artistic' in *Art in the Light of Mystery Wisdom* (Rudolf Steiner Press, London 1970).
13. See Rudolf Steiner, *Erdensterben und Weltenleben* (not translated), GA 181 (Rudolf Steiner Verlag, Dornach 1991), p. 313.
14. See further in: Judith von Halle, *Das Christliche aus dem Holze herausschlagen*, 2nd edition (Verlag am Goetheanum, Dornach 2008), p. 47 f.

Picture Credits

Cover images courtesy Foto Gmelin (Verlag am Goetheanum) and Atelier Heydebrand-Osthoff

Pages 4, 8: Gabriela de Carvalho

Pages 12, 20, 22, 23, 26, 27, 34, 43 (left), 45 (right), 49, 53, 56, 60 (top and bottom right), 61 (bottom left), 69, 72 (left), 76, 77, 78, 79, 80, 81, 84, 85, 86: Verlag am Goetheanum archive

Pages 13, 14, 16, 21, 29, 30, 31, 32, 37, 68, 72 (right), 74, 75, 90: Foto Rietmann (Verlag am Goetheanum)

Pages 17 (top left): Daniel van Bemmelen

Page 17 (top right and bottom): Zeichungen Archiv (Verlag am Goetheanum)

Pages 19, 24, 28, 33, 71: Atelier Heydebrand-Osthoff

Page 25: from Biesantz, Klingborb, *Das Goetheanum*, Dornach 1978

Pages 40, 41, 43 (right), 44, 45 (left), 46, 47, 52, 54, 57, 58, 59, 60 (left), 61 (top, bottom middle and right), 62, 63, 64 (left and top right), 65, 66, 67 (right): John Wilkes

Pages 42, 50, 51: Gmelin (Verlag am Goetheanum)

Page 64 (bottom right): Hans Gross (Verlag am Goetheanum)

Pages 67 (left), 73: from Rex Raab, *Edith Maryon*, Dornach 1993